Mendham, 20 Jun 99

IMAGES
of America

THE
MENDHAMS

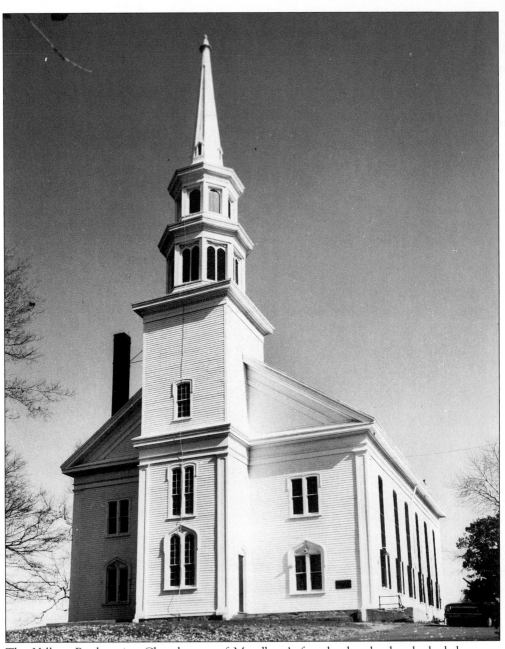

The Hilltop Presbyterian Church, one of Mendham's four landmarks, has looked down on Mendham from a knoll overlooking the village for almost two-and-a-half centuries. Two of the three buildings that predated this edifice built in 1860 were felled by lightning. The other landmarks are the Phoenix House, the Black Horse Inn, and the Ralston Store. (Presbyterian Church.)

IMAGES
of America

THE
MENDHAMS

John W. Rae

ARCADIA

Published by Arcadia Publishing,
an imprint of Tempus Publishing, Inc.
2 Cumberland Street
Charleston, SC 29401

Printed in Great Britain.

Library of Congress Catalog Card Number: 98-87448

For all general information contact Arcadia Publishing at:
Telephone 843-853-2070
Fax 843-853-0044
E-Mail arcadia@charleston.net

For customer service and orders:
Toll-Free 1-888-313-BOOK

Visit us on the internet at http://www.arcadiaimages.com

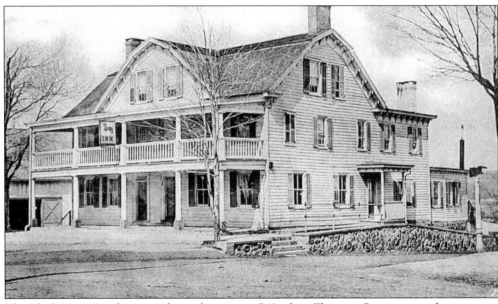

The Black Horse Inn has served travelers since 1743 when Ebenezer Byram opened a tavern in a house he enlarged. Succeeding owners made changes, but the inn still bears a strong resemblance to its mid-19th-century appearance. (Sally Foy.)

CONTENTS

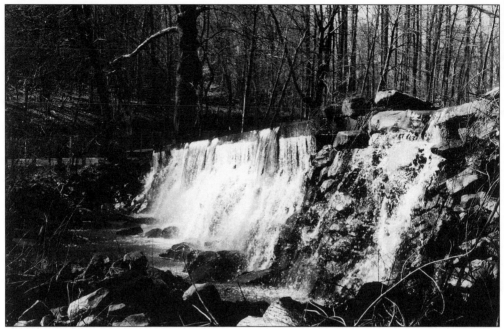

Water from the mill pond cascades over the dam at the site of the Leddell Grist Mill on Tempe Wick Road. Only remnants of the stone foundation of the mill mark the site where grain was ground for the Continental Army in the winter of 1779–80. (Author's Archives.)

ACKNOWLEDGMENTS

This photographic history marks the 250th anniversary of Mendham Township, a period that witnessed the early settlers, the Revolutionary War, the industrial revolution, the erection of great mansions, the incorporation of Mendham Borough in 1906, and the formation of government. It is not the work of one person, but of a long list of personages, historical societies, libraries, and town and county archivists who expressed enthusiastic support for a pictorial record of the past and delved into scrapbooks, nooks, and crannies for the many vintage images reproduced here.

It is hoped that from this effort comes a combined township and borough endeavor to collect and preserve in one location a historic record as part of our national heritage before it is lost or destroyed, as has been so much of the material and photographs that tell the story of our ancestry. It is sad, but the steady march of suburbanization is slowly destroying what was, and today's generation seems less and less interested in preserving what little remains.

John W. Rae

INTRODUCTION

More than 250 years ago, the footprints of the Lenni Lenape Indians, the forebears of an expanding population that today has changed the Mendhams from rural to suburban, were the only sign of man traversing the area on the Minnisink Path, or living by the North Branch of the Raritan River. The first to follow them were the trappers from New Amsterdam, then the early settlers from New England who built their homes and established farms in Roxiticus, now known as Ralston.

These images reveal an enigmatic, aggressive area, its rise to prominence as a sleepy agricultural New Jersey village, its fight for survival when its industries failed, and its rise to prominence as one of the country's leading suburban areas. Herein are illustrated the drama and pathos of a great sweep of events, illuminating sidelights, oddities, and amusing trifles, all of which combine to make a full image of the Mendhams.

The township originally composed the borough incorporated in 1906 and four hamlets: Brookside, formerly Waterstreet, the site of early industries; Washington Corners near Jockey Hollow, the site of Revolutionary War encampments; Ralston, formerly Roxiticus, the earliest settlement; and Pleasant Valley, site of mills, farms, and estates.

Incorporated in 1749, the township, which originally included Randolph and most of Chester, was sparsely settled through the dawn of the 18th century. Its roads were dirt, many no more than a trail; its transportation, stages; its houses small and of frame construction, many of them patterned on the East Jersey Colonial style; and its industries small, supplying the everyday basic needs of the Mendhams' 1,724 residents in 1905.

The source of power for these early industries came from three major rivers that rise in the region: the Whippany River, near Brookside, the Passaic River in the borough, and the North Branch of the Raritan River, fed by Burnet, Indian, and McVicker's brooks as it flows through Ralston.

Tax ratable tables for 1779 illustrate the early industrial growth. There were six gristmills, ten stills, four sawmills, and seven forges, iron for which was brought to Mendham where at least one mine was located, on horseback over the Minnisink Path from surface mines at Succasunna.

By the early 1800s small industries were booming. One, a cotton and woolen factory, the first of its kind in New Jersey, started by John Ralston, operated until 1840. There were private education academies for both sexes, blacksmith, nail-making, shoe, and wheelwright shops, carriage, carpet, glass, chair and rug weaving factories; fulling, weaving, dyeing, grist- and

sawmills; forges, lime kilns, cement quarries, mica, lead, and copper mines, one of the latter of which reportedly minted Continental pennies; tanneries and lumbering and logging.

These industries, none of which had large numbers of employees, could not withstand cheap competition. With the advent of the railroad after the Civil War, the area reverted to agriculture. The Rock-A-Bye Baby Railroad, a single track line built in 1888 from Whitehouse to the Watnong depot, just short of connection with the Lackawanna Railroad at Morristown, gave a brief spurt to the area's transportation needs through 1917, then went bankrupt.

With the loss of industry, the Mendhams returned to agriculture, raising large quantities of apples to distill into applejack until the Volstead Act of 1919 ushered in Prohibition. Meanwhile, large mansions were being constructed for millionaire tycoons, especially on the Mendham Borough slope of Bernardsville Mountain, Washington Valley, and the ridge on the township's western fringe.

Earlier, stone, brick, and frame one-room schoolhouses sprang up throughout the township teaching all grades. Pupils often walked 3 miles to school in good weather, or were transported to class in horse-drawn sleds in the winter months, when the only heat in the classroom was a pot-bellied stove. By the 1930s, many schools had been closed and larger ones were built. Seniors attended Morristown High School, traveling there on the Rock-A-Bye Baby Railroad and early buses.

It was the dawn of the 20th century that saw the real beginning of Mendham as a village shopping center; highways were paved, new roads constructed, and post offices established. Masons and brick layers were brought from Italy and England to build the millionaires' mansions, a water system and reservoir were built, fire departments were formed, and a bus line was incorporated. The railroad was built, frail as it was, and new homes and office buildings were constructed, many by masons who came to build the mansions for the wealthy.

Today on almost every knoll and hilltop rises a $1 million-plus mansion where once there were only trees and fields. Elsewhere, clusters of middle and upper class suburban homes, some large, others small, have broken up the once green pastures and fields, blocking the views of distant hills.

But it is its heritage that makes the Mendhams so rich and unique. It is hard to locate in this country another area adjacent to a National Historic Park so small that has four historic districts preserving many of the original homes and buildings.

John W. Rae

One

RALSTON

THE FIRST FOOTPRINTS

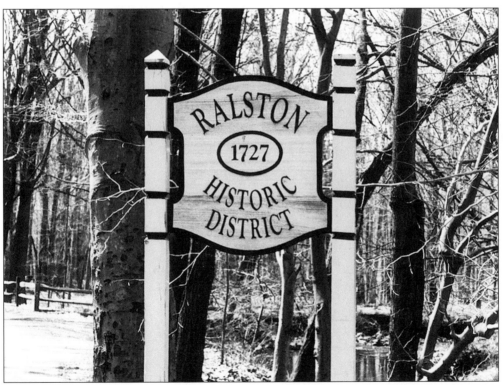

This view is of the Ralston Historic District marker. One of the first historical districts in New Jersey, it centered about the Ralston Grist Mill, General Store and Post Office, and Ralston Manor House, when created in May 1975. It was enlarged in March 1997 to include other historical buildings and sites.(Author's Archives.)

Built in 1720, the Ralston Manor House, 114 acres, and the Logan grist- and sawmill were purchased by John Ralston, a Philadelphia merchant, in 1786 from John Logan, who operated it during the Revolutionary War supplying the Continental Army with grain. Letters discovered in the slave quarters indicate he carried on an extensive business between Ralston, Mendham, New York, and Augusta, Georgia. (Ralston Historical Assn.)

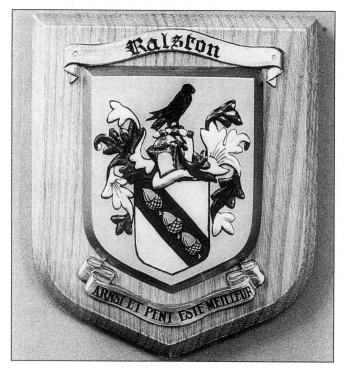

The Ralston Coat of Arms depicts a bald eagle beneath the name Ralston. The motto, "Arnsi et pent este meilleur," is interpreted: "we are thus, but we would be better." (Township Archives.)

Built in 1776, the Ralston General Store and Post Office, the oldest post office building in the United States, was a major factor in making the crossroads at Ralston the business center of the Mendhams in the 1700s. Merchandise ranged from iron, peach brandy, and hats, to molasses, tobacco, and ladies' silk handkerchiefs. From 1892 to 1941 it served as the post office. (Ralston Historical Assn.)

The United States Post Office Department issued a commemorative envelope in 1938 for philatelists with a black and white image of the one-room frame post office, denoting it as "the oldest post office building in the U.S." It is now a museum operated by the Ralston Historical Association. (Ralston Historical Assn.)

The Ralston Feed and Grain Mill and adjacent millers' house on the North Branch of the Raritan River astride the crossroads at Ralston in 1900 show the Morristown Road, now Route 24, still a dirt road. Known to be operated as early as 1742 by Edmond Martin, it was later acquired by John Logan, John Ralston, John Nesbitt, and D.C. Apgar. (Ralston Historical Assn.)

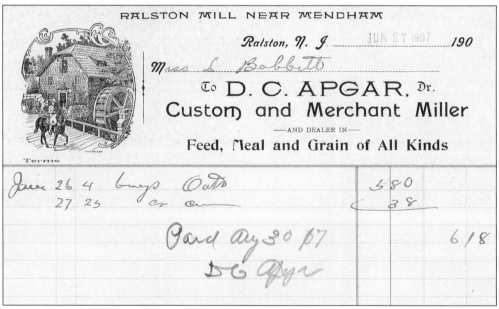

Shown is a 1907 bill from the Ralston Feed and Grain Mill, then operated by D.C. Apgar who described himself as "a custom and merchant miller, a dealer in feed, meal and grain of all kinds." The bill is issued to Miss L. Babbitt for $6.18 for four bags of oats bought June 26 and lesser items purchased June 27. (Mendham Historical Society.)

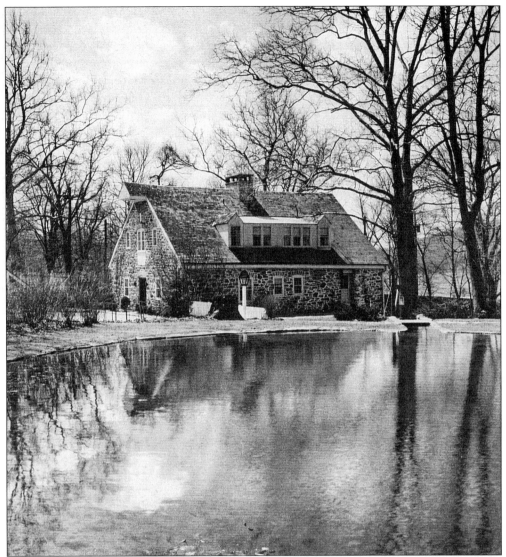

Logan Grist and Feed Mill on the North Branch of the Raritan River at Ralston which supplied the Continental Army at Jockey Hollow in 1779–80 with grain, was converted to an eight-room home in 1940. It is listed in the Library of Congress archives as one of the 30 oldest dwellings in New Jersey, "possessing exceptional historic or architectural interest worthy of preservation." (Author's Archives.)

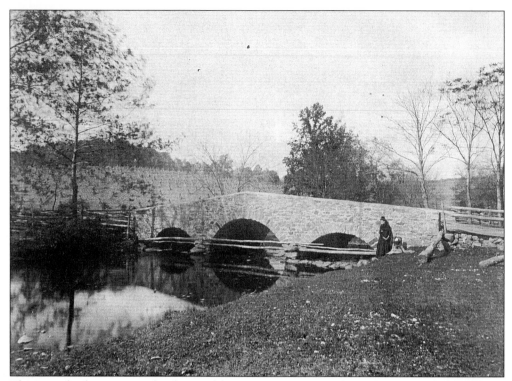

The stone bridge carrying the dirt road between Morristown, the county seat of government, and the Mendhams and Chesters, over the North Branch of the Raritan River at Ralston was severely damaged in a flash flood in 1896. It was replaced with a steel single span truss bridge. (Bernardsville Library.)

This steel single span truss bridge was erected in 1896 to replace the damaged stone arch bridge. One of the first erected in southeastern Morris County, it remained in service until the existing concrete bridge was built. (Ralston Historical Assn.)

A horse and carriage stand in the narrow dirt road, now Route 24, in front of the General Store and Post Office at the four corners in Ralston in the late 1890s. The view is from the Peapack Gladstone Road, now Roxiticus Road. The millers' house for the Ralston Feed and Grain Mill is at the left. (Ralston Historical Assn.)

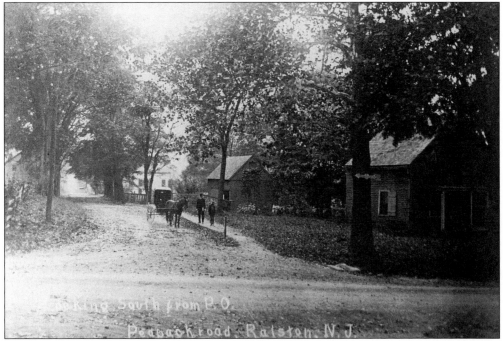

A horse and carriage stand in the dirt Peapack Gladstone Road at the four corners at Ralston in the late 1890s while its occupants confer on the sidewalk. The view is looking south from the steps of the General Store and Post Office. (Ralston Historical Assn.)

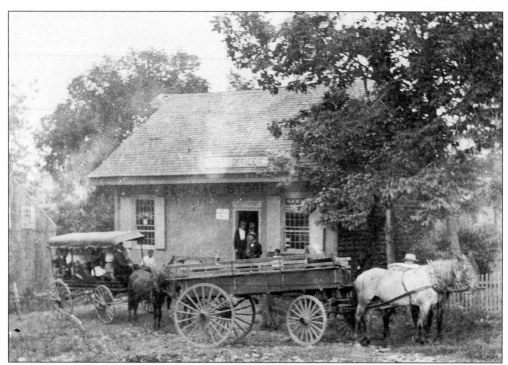

A carriage taking Sunday school children to a picnic pauses before the General Store and Post Office in Ralston in the 1890s. A farm wagon and horse is ahead of it, one of its occupants tending the horse, the others emerging from the general store. (Township Archives.)

In the winter months when roads were covered with snow, horse-drawn sleds were the only method of transporting children to school at the turn of the century. Here a sled drawn by a team of horses takes Ralston children to class. (Township Archives.)

Construction of St. John the Baptist Convent on a 30-acre tract on Route 24, Ralston, started shortly after the sisters moved from New York to Mendham Township in 1913. Completed in 1915, it once contained a tuberculosis infirmary and an Episcopal preparatory girls boarding school (closed) operated by the sisterhood in a building constructed in 1929. (St. John Convent.)

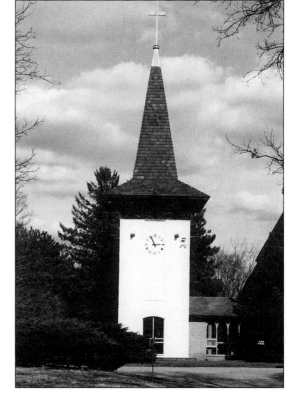

This view is of the clock tower in front of St. John the Baptist School on Route 24, Ralston. The school operated by the sisters closed in 1983. It is now Daytop House, an adolescent substance abuse program center. (Author's Archives.)

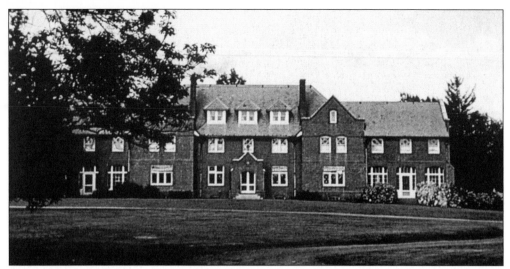

Pictured is St. Marguerite's Retreat House at St. John the Baptist Convent, Route 24, Ralston. The three-story brick center section with its two-story wings, faces the Convent with its soaring Gothic arches across a large circular area. (Sally Foy.)

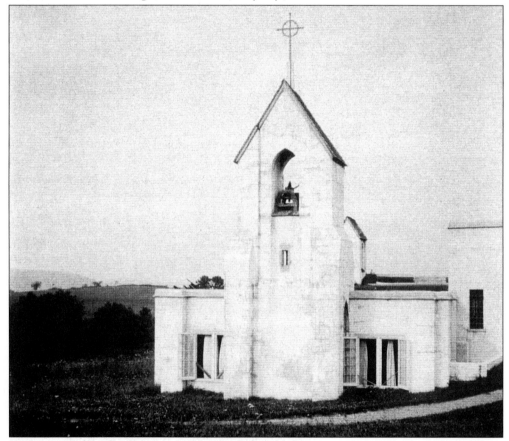

The first bell tower at St. John the Baptist Convent was built c. 1920. It has been incorporated into the larger structure of the convent. (St. John Convent.)

Shown here is one of early residences, a plain Victorian house off Route 24, Ralston, occupied by the sisters of St. John the Baptist Convent while the convent was being constructed. (Sally Foy.)

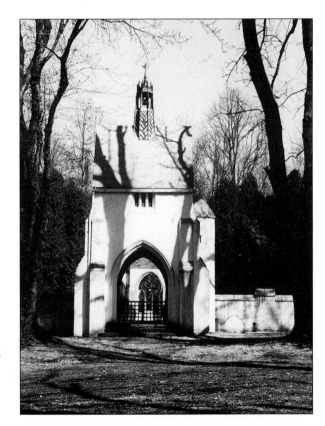

The entrance to the graveyard at St. John the Baptist Convent has a towering Gothic entranceway matched by another similar in construction at the rear of the cemetery. (Author's Archives.)

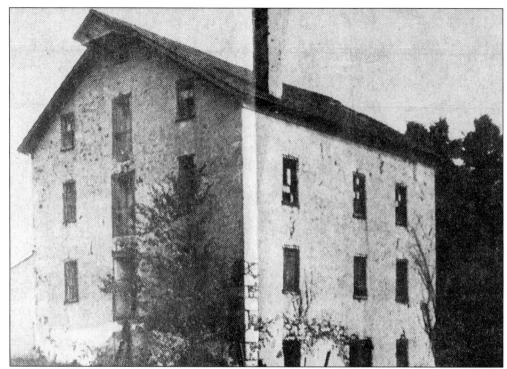

Historically the Mendhams were noted for a large number of distilleries. One in particular, the Laughlin distillery purchased in 1899 by Thomas J. Laughlin, was noted for its "Jersey Lightning," better known as applejack. Still standing on Route 24, Ralston, in the John R. Nesbitt mill, it operated until the Volstead Act of 1919, ushering in Prohibition, forced its closure. (Township Archives.)

A water wheel shaft at Laughlin distillery on Route 24, Ralston is turned by water from a mill race. A large water wheel turned the shaft generating power for the distillery. (Township Archives.)

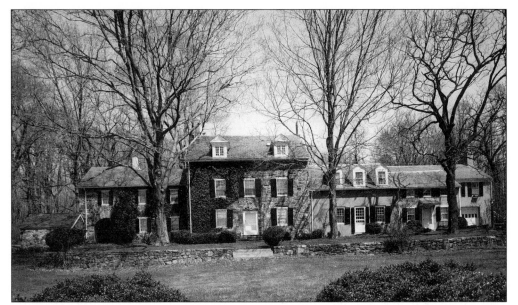

The pre-Revolutionary War "Old Stone Farm," an early stone Colonial constructed of field stone and stucco with a slate roof on Stone House Road, Ralston, *c.* 1738, was built for John Logan, an early owner of the Ralston Feed and Grain Mill. Originally, entry was from Ironia Road via a bridge over the North Branch of the Raritan River. (Turpin Realtors.)

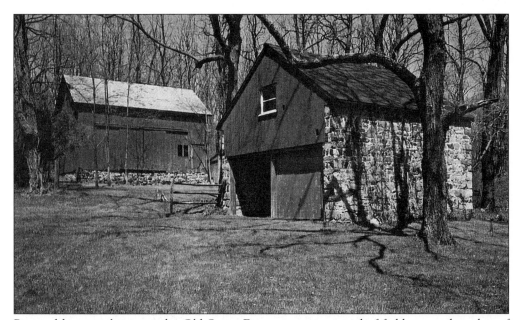

Pictured here are barns on the Old Stone Farm, one constructed of field stone, the other of wood. It was here that John Ralston enroute to visit John Logan saw Margaret Logan, Logan's daughter, ride into the yard on horseback. He fell in love with her. The couple, married in 1785, moved into the Ralston Manor House where they raised seven children. (Author's Archives.)

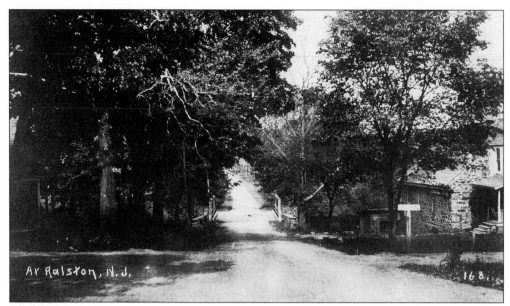

The dirt road pictured here looking west from the crossroads at Ralston in 1900 is now Route 24. In the distance is the steel span bridge over the North Branch of the Raritan River erected in 1896 to replace a span damaged in a flash flood. To the right is the millers' house and the Ralston Feed and Grain Mill. (Author's Archives.)

Ruins of the Gronewegen rug-weaving shed on Roxiticus Road, Ralston, depict a business which prospered at the turn of the century. It obtained its fibers from a cotton and woolen mill farther south on Roxiticus Road founded by John Ralston. It was typical of many small industries that sprang up in the Mendhams. Today, none survive. (Wilma Sagurton.)

22

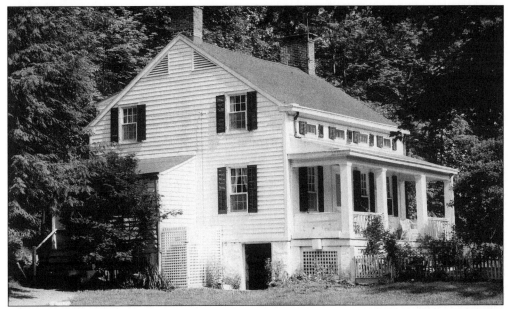

Built by Aaron Hudson, Mendham's architect/builder, for Calvin Willet, a blacksmith and toolmaker, the two-story house on Roxiticus Road, Ralston, has a row of carefully proportioned windows and shutters above a wide front porch with railings of slanted spindles. (Township Archives.)

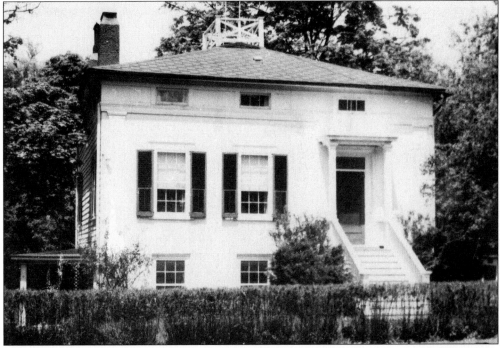

Its design inspired by villas in France, the Russell Carter house on Roxiticus Road, Ralston, on land between the North Branch of the Raritan River and the road, was designed and built by Aaron Hudson, in the mid-1800s. It is similar to the Nicholas house, also designed and built by Hudson on New Street, Mendham Borough. (Township Archives.)

Built in 1934 for August Belmont, world-famous horseracing figure and breeder, "Willow Springs Farm" on Roxiticus Road, Ralston, is a white brick Georgian Colonial surrounded by 12 acres of rolling hills, pastures, and woodlands. A sunken 24-x17-foot living room with 12-foot ceilings and a carved wooden fireplace overlooks a pond. (Turpin Realtors.)

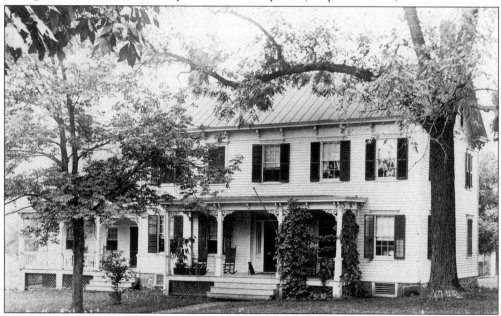

One of the oldest houses in Ralston, the residence of Calvin Davis, built in 1749 on Route 24, Ralston, was once decorated with murals painted by Davis, a primitive artist. He lived in the house with Jessie Willet, the Union School teacher. (Township Archives.)

Members of Ralston Engine Company construct their first firehouse on Route 24, a two-bay cinder block building close to the North Branch of the Raritan River. A second and larger fire house has since been constructed adjacent to it. (Ralston Fire Co.)

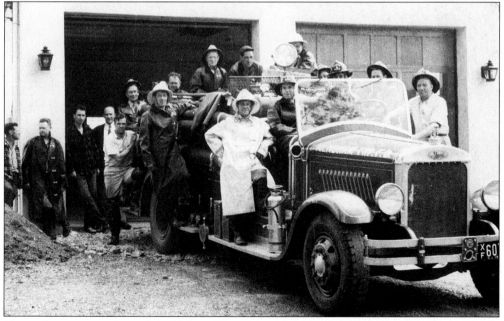

Shown here are members of the Ralston Fire Company on their fire truck emblazoned with the words "Mendham Township F.D." on the hood in 1949 outside the firehouse they constructed on Route 24. (Township Archives.)

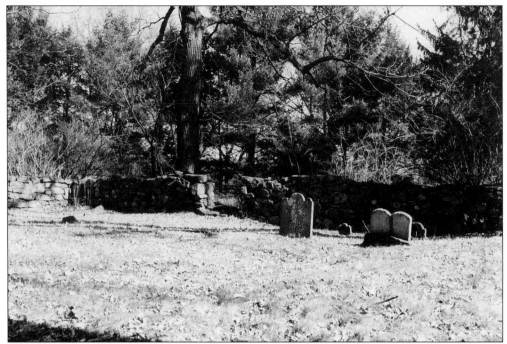

The Wills family cemetery, a 25-square-foot plot enclosed by 4-foot field stone walls at Route 24 and Oak Knoll Drive, is part of the tract originally purchased by James Wills in 1713 in Roxiticus, now Ralston. Only four headstones survive, two large ones: one a double headstone, and two small ones. (Author's Archives.)

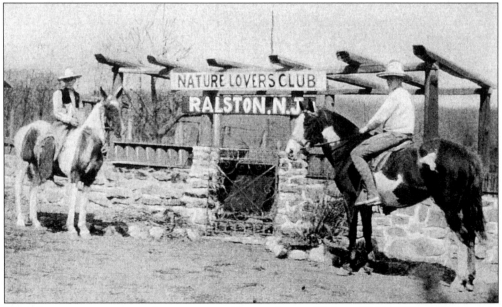

These horsemen are seen at the entrance to Natures Lovers Club on Old Mill Road, Ralston, in the 1930s. The large group of men and women, mostly from the city, dammed a brook, creating a small lake for swimming, and built houses and a baseball diamond. The buildings were razed, and it is now the site of Mendham Township's Meadow Wood Park. (Sally Foy.)

Two

THE TOWNSHIP

250 YEARS YOUNG

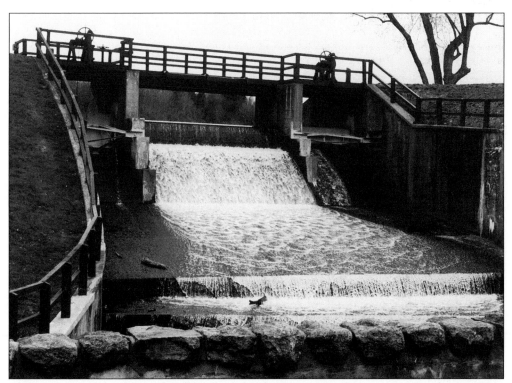

This is a view of the dam and spillway built by the Boyscouts of America at Brookrace to trap the waters of McVicker's Brook. It was named Lake Therese in honor of Mortimer L. Schiff's mother, who purchased the site in 1932 for the scouts to use as their national training center as a memorial to her son. (Author's Archives.)

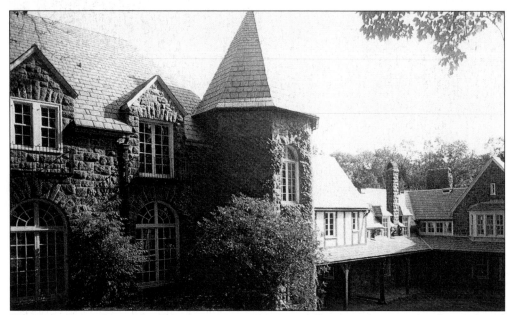

"Brookrace" was designed and built in 1914–18 in two different architectural styles, Colonial Revival and French Eclectic, by three notable American architects: Ernest Flagg, McKim, Mead & White, and Aymar Embury. It was built for Richard Williams as a wedding gift for his son. It is named after a mill race along McVicker's brook. (Brookrace.)

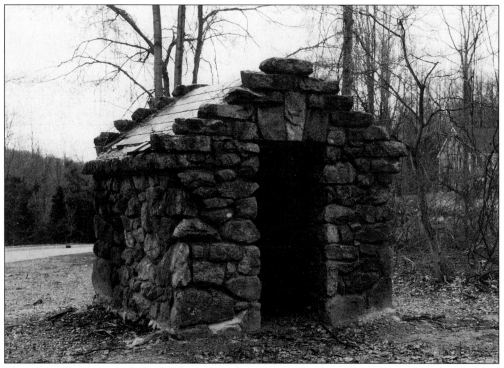

The spring house, on a hillside above Brookrace, is built of rough-hewn pink granite with a gabled roof with red clay tiles. (Author's Archives.)

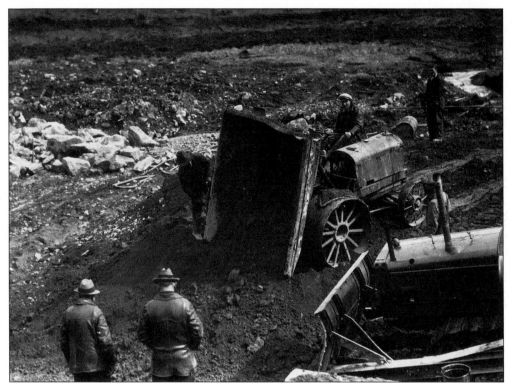

Workmen construct a dam at Lake Therese, which was formed by damming McVicker's Brook, after Boy Scouts occupied the Richard Williams estate in 1933. Termed "the most notable and spectacular improvement" at what became the Schiff National Boy Scout Reservation, it was once the site of a small mill pond. (Brookrace.)

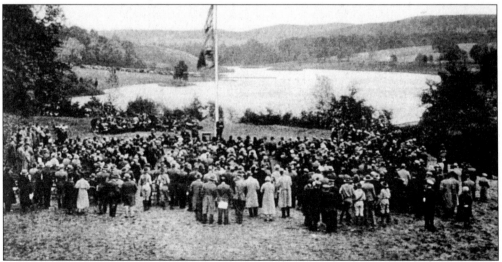

The dedication of Schiff Boy Scout Reservation and National Training Center, once the 491-acre Richard Williams estate, took place on October 13, 1933 on a hillside overlooking Lake Therese. The estate was purchased for $75,000 by Mrs. Jacob H. Schiff as memorial to her son, the fifth president of the Boy Scouts of America, who died one month after assuming office. (Sally Foy.)

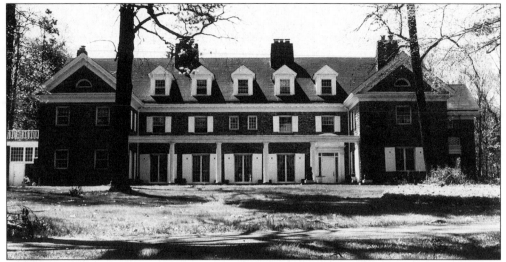

Franklin Farms is a 205-acre estate created in 1914, straddling the Mendham Borough-Township line, by former New Jersey Governor Franklin Murphy (1902–1905). The large Revival-style mansion faced Route 24 behind a granite 4-foot wall and expansive lawns. A carriage house was in the front of the property and a dairy barn complex (razed) was behind it. (Author's Archives.)

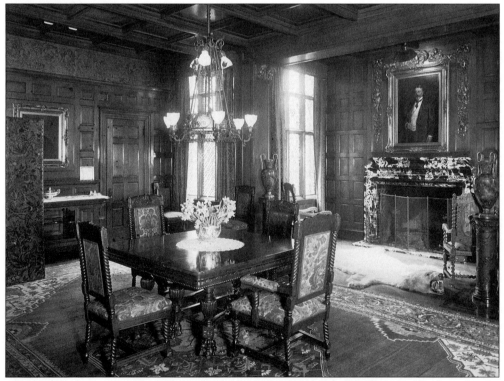

The dining room at Franklin Farms is shown here c. 1915 with a bearskin rug (the bear shot by the governor on a hunting trip) in front of an Onyx fireplace with the governor's portrait over it. There was a floor-to-ceiling pipe organ in the great hall, a large library, a living room, and extensive porches. (Township Archives.)

The gardens were designed by the Olmstead Bros., designers of New York's Central Park, at the rear of the Franklin Farms mansion. The gardens and dairy complex are gone, and only the mansion with 23 acres surrounding it remains. It is scheduled for subdivision. (Author's Archives.)

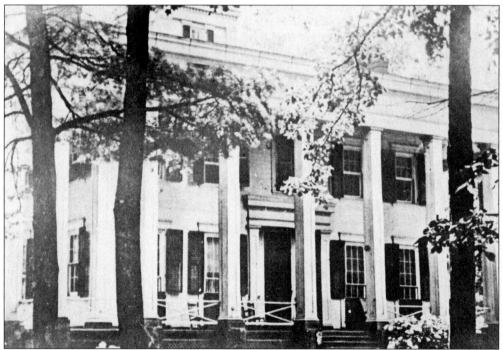

The largest country house designed and built by Aaron Hudson was for the stepson of the Presbyterian parson, who had inherited $60,000, and desired the finest house in Mendham. However, once built on the site of Franklin Farms, he could not afford its upkeep and sold it to Francis Oliver who renamed it Oliver Hall and operated it as a boarding house. Murphy razed it for his mansion. (Township Archives.)

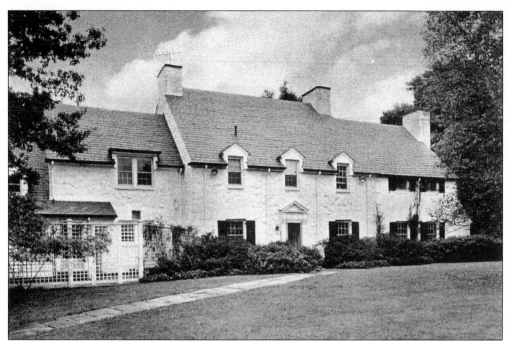

Beverly Farms, an authentic Pennsylvania Colonial farmhouse, was built in 1932 on 15 acres on Corey Lane. It was made of stone, handsplit shingles, brick, and steel, and it had a heavy slate roof. It has a pine-paneled center hall, a 7-foot fireplace with crane, an oakbeamed ceiling, a 29-x19-foot living room, and a guest cottage. Included also are a barn, silo, corn crib, feed and wood sheds, and a pump house. (Turpin Realtors.)

This small farmhouse on West Main Street, once the core of a large farm, had tunnels which led under Route 24 as part of the Underground Railroad. (Mrs. Barbara Doremus.)

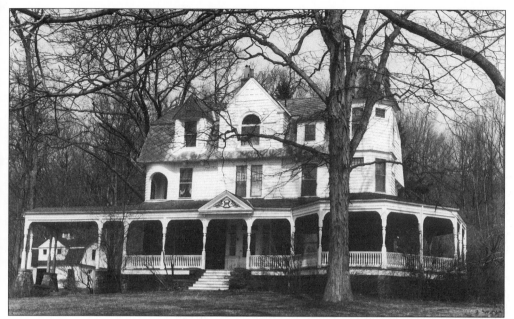

Somerhurst, a Victorian residence on Mountainside Road, Mendham Township, was built in 1888 by Joseph Somers as a summer retreat. The date of construction is carved in the pediment over the front-porch entry. Its size, extravagance, and furnishings both startled and amazed local residents. (Author's Archives.)

Built in the early 19th century, River House is a two-and-a-half-story home with a wide front porch by McVicker's Brook at the intersection of Union Schoolhouse and Pleasant Valley Roads. A residence during the estate era, it had a sawmill built east of it in 1868. Traces of the mill race are still visible. (Author's Archives.)

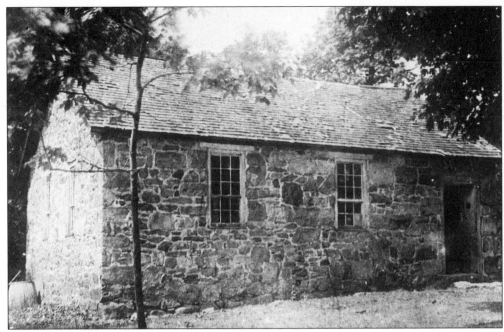

One of the earliest Mendham Township schools was the Homan or Mountain stone school on Mountainside Road, near India Brook. Built on land deeded to the Board of Education by Joel Homan in 1844, it was closed in 1906. It had an average enrollment of 28 pupils. It has been converted into a residence. (Author's Archives.)

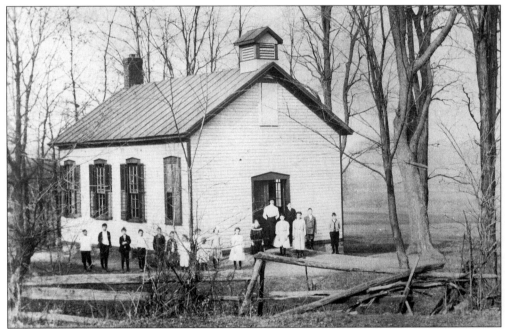

Washington Corner School, at the intersection of Corey Lane and Tempe Wick Road, was built in 1876. It had an enrollment of 30 students who, in the winter, depended upon a pot-bellied stove for heat. Closed in 1913, it was sold for $620 in 1923, two years before it was converted into a residence. (Township Archives.)

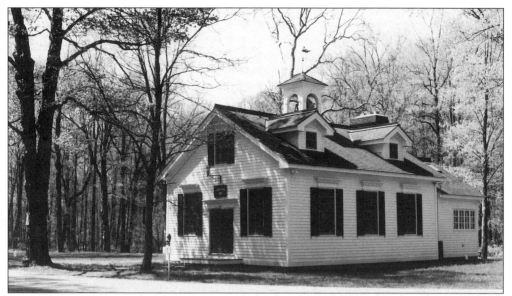

The Union School at the intersection of Pleasant Valley, Mosele, and Schoolhouse Roads, built in 1851, had 35 to 40 pupils enrolled in grades one through eight, many of whom walked 1 to 3 miles to school. The one-room schoolhouse closed in 1928 and was leased for several years, then sold in 1941 to the Schiff Scout Reservation. (Author's Archives.)

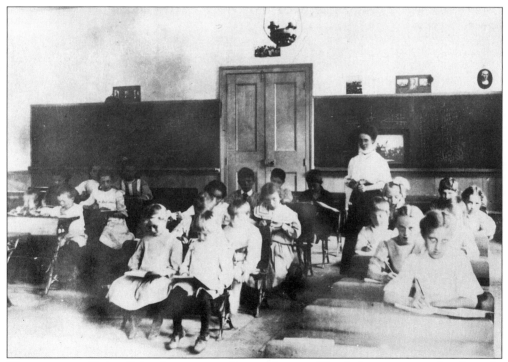

The one-room Union School was not a thing of beauty. The desks were marred and rough, slates were used instead of paper, and the few books available were used year after year. Pupils learned to write by copying material over and over again. Any other material for keeping them busy was improvised by the teacher. (Township Archives.)

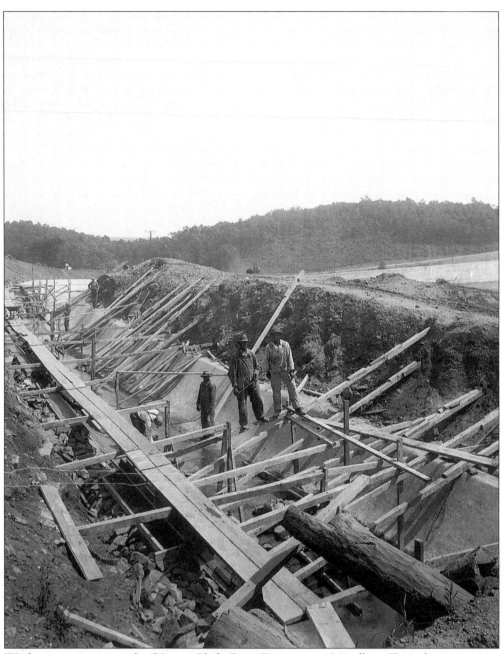

Workmen constructing the 56-acre Clyde Potts Reservoir in Mendham Township as a water supply for Morristown in 1929 built a large earthen dam at Woodland Road in Harmony Hollow. The purpose of the dam was to trap the waters of Harmony Brook, and it was named for a former Morristown mayor. (Southeast Morris MUA.)

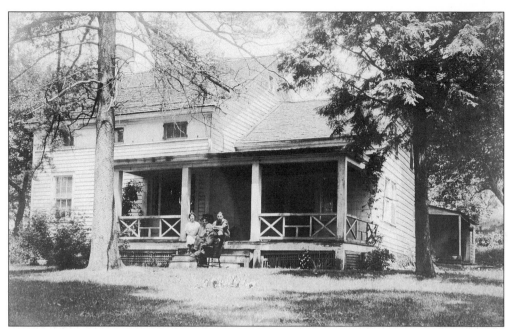

Shown here is the Frank Goff family on the porch of their farmhouse in Harmony Hollow, Mendham Township. The land was taken to construct the Clyde Potts Reservoir in 1929 as a water supply for Morristown. He supplied poultry and eggs to the (at that time) hotels in Mt. Freedom. (Mrs. Myrtle Creran.)

The main dirt road through Harmony Hollow, Mendham Township, and Frank Goff's barns was razed in 1929 to provide land for Clyde Potts Reservoir. The frame barns and Goff farmhouse today would be covered by 45 feet of water. (Mrs. Myrtle Creran.)

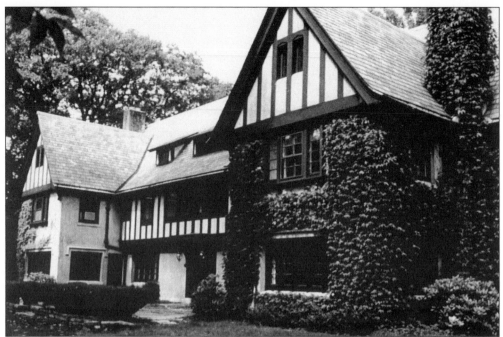

Glenowre, a Tudor-style mansion, was built on Mountainside Road, Mendham Township, in 1908 for Daniel E. Moran, a civil engineer who specialized in designing foundations for tall and difficult-to-construct structures. Included were the Woolworth Building, the tallest Woolworth in the world when completed in 1912, and the George Washington and San Francisco Oakland Bay bridges. (Robert Gates.)

This ornate hand-carved wooden banister is found in Glenowre. (Robert Gates.)

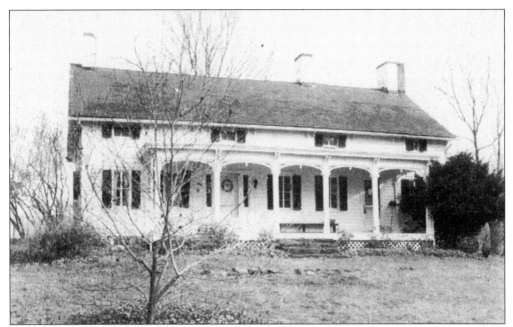

This East Jersey-style frame Colonial farmhouse was built in 1807 on Combs Hollow Road, Mendham Township as the center of a 200-acre farm. The date of construction is emblazoned on a plaque mounted on the front of the house; the porch was added in 1860. All the farm buildings, except a corn crib, have long since disappeared. (Turpin Realtors.)

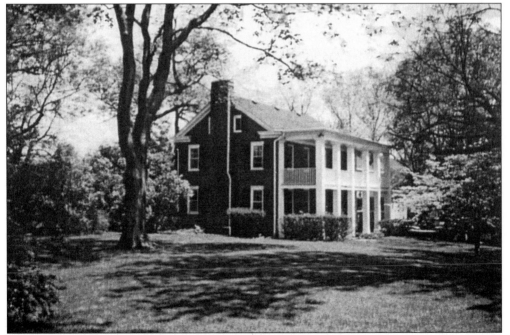

Sundial Farm, a Georgian-style house with a Greek Revival double-height portico, was built in 1800 and enlarged in the 1860s at 330 Mendham Road, Ralston. The ten-room residence with original pine floors, high ceilings, and a beehive oven has the original stone barn. (Turpin Realtors.)

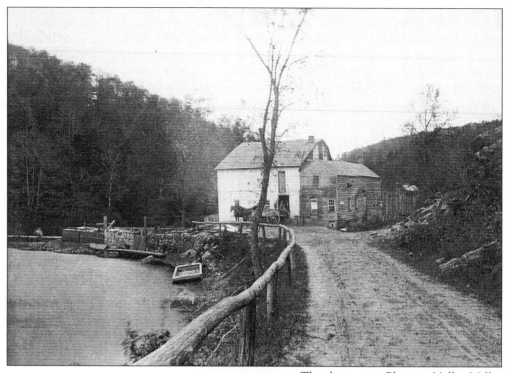

The three-story Pleasant Valley Mill, originally a fulling mill, was operated by David Apgar as a gristmill at the turn of the century. Located on the banks of the North Branch of the Raritan River at the intersection of Mosele and Roxiticus Roads, Mendham Township, north of the Union School, it had a two-story attached storage shed for grain. (Township Archives.)

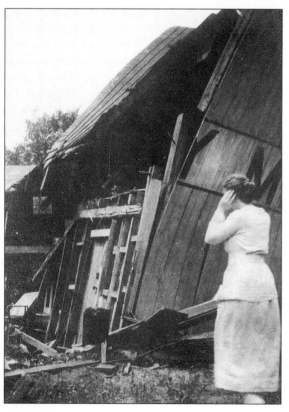

The twisted remains of the Pleasant Valley Mill are shown after a flash flood uprooted trees on the banks of the North Branch of the Raritan River, smashed the mill pond dam, and demolished the mill in July 1919. (Township Archives.)

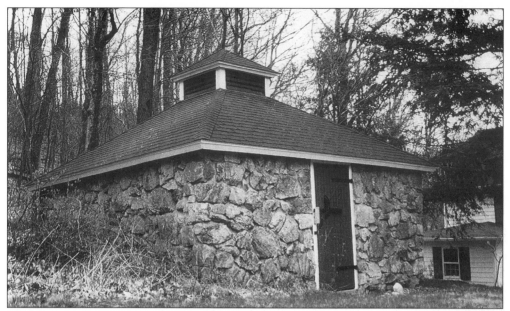

This stone ice house was on the property of Dr. Leslie Schlessinger on Mosley Road, Mendham Township. Ice was cut from ponds in the winter months and stored in ice houses for use in the summer months. It was packed in sawdust or layers of straw to prevent it from thawing. (Township Archives.)

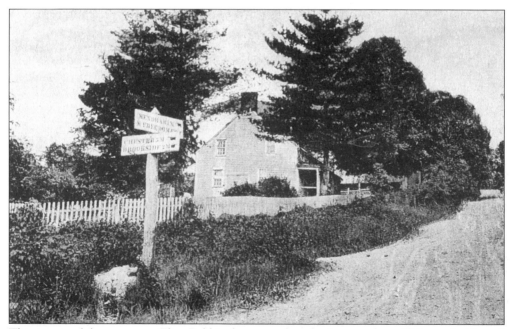

This image of the two-story Elias Babbitt homestead at the intersection of Mountainside and Calais Roads shows the type of narrow dirt roads, often no more than a trail, that prevailed throughout the Mendhams in the 1800s. (Ralston Historical Assn.)

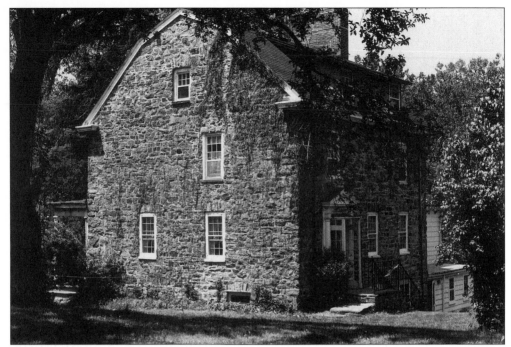

The Leddell homestead on Tempe Wick Road, Mendham Township, next to the Leddell Grist Mill, supplied feed and grain to the Continental Army encamped in nearby Jockey Hollow during the winter of 1779–80. Built after the first house, a frame structure burned in 1816, it is constructed of stones collected from the campfire sites of the troops in Jockey Hollow. (Township Archives.)

The Sutton tack shop and chair factory was operated in a small two-story barn and house in Corey Lane, Mendham Township, supplying chairs of all kinds to area residents.(Township Archives.)

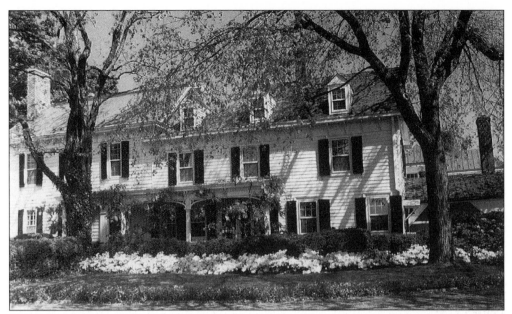

The Pitney Homestead on Cold Hill Road, Mendham Township, the only residence in the Township to remain in one family since being built as a pre-Revolutionary War farmhouse, prior to its recent subdivision, was one of the larger estates in Mendham Township. (Duncan Pitney.)

The garden entrance to the Pitney estate, in recent years approached by a long maple tree-lined driveway from Route 24, is now closed by the subdivision that takes up much of the property. (Duncan Pitney.)

This is another view of the Leddell Mill on Tempe Wick Road, Mendham Township, which ground grain and flour for the Continental Army encamped in nearby Jockey Hollow in the winter of 1779–80. Supplementing a primitive mill suited to the needs of early settlers, it provided a saw- and wood-turning mill, a gristmill, and a stronger dam. (Morristown Library.)

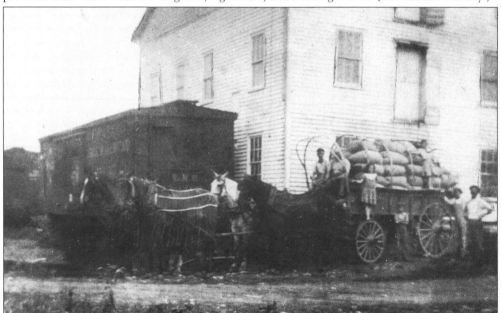

Day's Grist Mill, a three-story frame structure, on the lower end of Tingley Road at the Washington Valley end of East Main Street, Brookside, was built in 1869 by George Connet. Operated for years by Ephriam Day and his son Charles, it was powered by water from a pond created by damming the Whippany River. (Township Archives.)

This was originally a Dutch Colonial farmhouse built *c.* 1902 for Dr. Samuel Cox Hooker on a 100-acre tract on Mountainside Road, Mendham Township. Hooker used it as a summer residence. The porch and pond were added at a later date. The cedar barns adjacent to Calais Road, where Hooker bred sheep, predate the house by 20 years. (Margaret D. Holtan.)

Built in 1774 on a 90-acre tract, the small-frame Daniel Dod home at the corner of Calais and Mountainside Roads was part of the Hooker estate. (Margaret D. Holtan.)

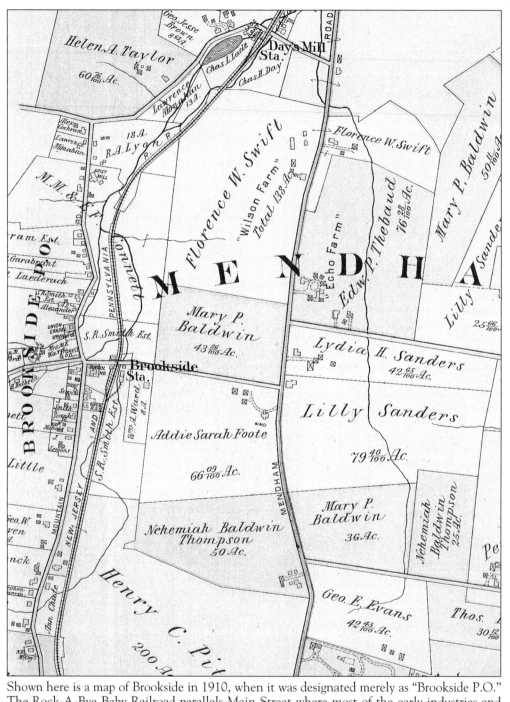

Shown here is a map of Brookside in 1910, when it was designated merely as "Brookside P.O."
The Rock-A-Bye Baby Railroad parallels Main Street where most of the early industries and
homes were built. The depot, a converted caboose, and railroad sidings were at Cherry Lane.
Stops were made twice daily at Day's Mill, Whitehead Road, Washington Valley Road, Sussex
Avenue, and Cold Hill Road. (A.M. Mueller Atlas.)

Three

BROOKSIDE

ITS RESIDENTS AND INDUSTRIES

This image is of the Brookside Historic District marker. The district, approved in 1995, encompasses 37 properties on East and West Main Street (originally called Water Street), Tingley Road, and Cherry Lane. (Author's Archives.)

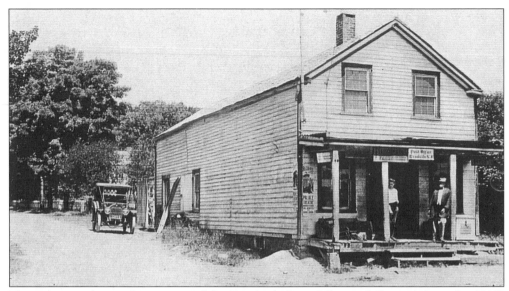

The sign over the porch entrance of the Brookside Post Office and General Store (*c.* 1910) reads: "Post Office, Brookside, N.J." While the roads have been paved, the two-story frame building at the intersection of East and West Main Streets, Cherry Lane, and Woodland Road is little changed today. (Ralston Historical Assn.)

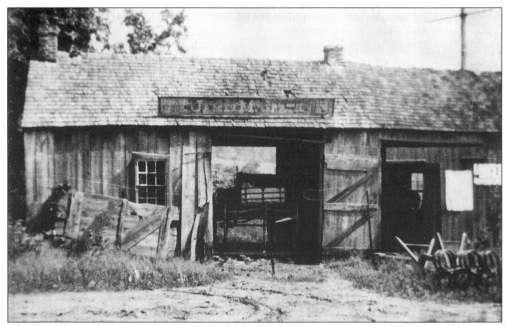

The McGrath blacksmith shop was operated by J.H. McGrath across from the Connet gristmill on Main Street, Brookside. An account book dated 1887–88 listed charges for blacksmith work: Two new shoes, 50¢; two-foot scrapers, 50¢; barn door hinges, 30¢, and fixing a metal bedstead, 25¢. (Township Archives.)

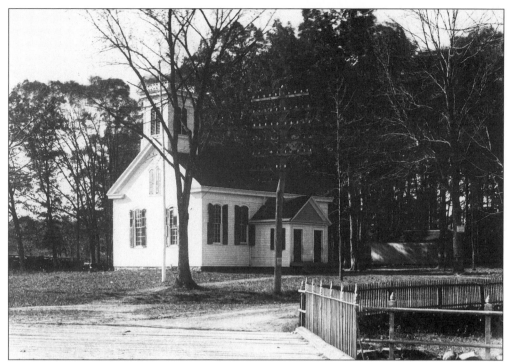

The Brookside School, a one-room frame building situated where the present Township Municipal Building is located, was built in 1860. By 1878–79 its enrollment had swelled to 100. In 1899, it was divided into two rooms with entrances on the sides of the building. And, in 1923 a new four-room structure was erected on the site at a cost of $25,000. (Township Archives.)

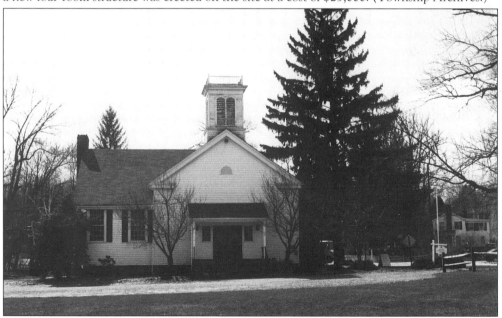

When the new four-room school was built in 1923, the existing two-room building was sold to Frederick G. Kiser for $455 and moved across Cherry Lane to the Community Club grounds where it formed the core of the Community House. (Author's Archives.)

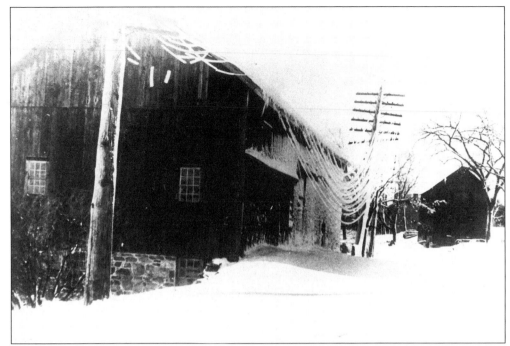

This view is of the Jesse Smith Grist Mill on Main Street, Brookside, after a winter storm felled wires. The mill was later operated by Madison Connet and his son Stephen. One of the oldest mills in the area, it was built by Smith between 1745 and 1750. It was powered by water from Dismal Brook. (Morristown Library.)

A sawmill on what is now Woodland Avenue, Brookside, was built by Stephen Connet in 1842. Operated for many years by Connet and his son Manning, it made brush blocks, lumber, and peach baskets. Closed after the turn of the century, it was converted into a residence. (Township Archives.)

Every Fourth of July for 75 years Brookside has held a parade attracting bands, fire equipment, and spectators from a wide area. For many years residents vied to construct elaborate full-scale floats, ranging from side wheel paddle boats to trolleys and a minstrel show boat often in their yards. The trolley was constructed by Ernie Maw in 1976. (S. Charles Greidanus.)

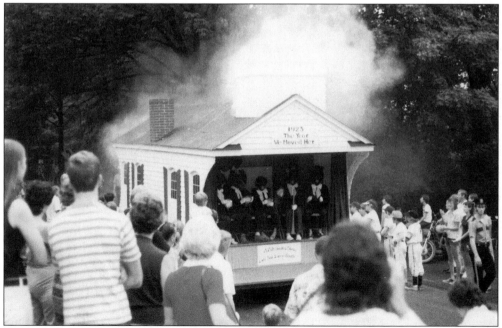

The minstrel show, also constructed by Maw, puffs its way down East Main Street, Brookside, the minstrels playing their instruments to the cheers of bystanders. (Debbie Mills.)

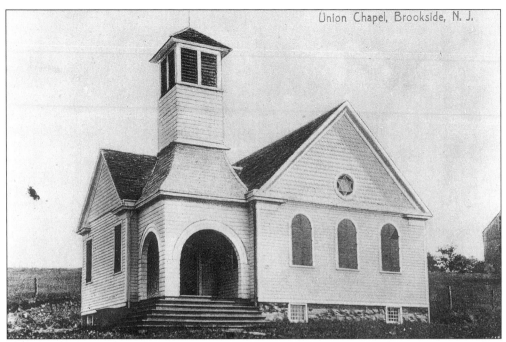

The frame Union Chapel on East Main Street, Brookside, opposite the Community Club grounds, was built in 1898 and dedicated on March 8, 1899. In its infancy it was serviced by ministers from area churches. It was destroyed in a raging fire on December 20, 1942. (Township Archives.)

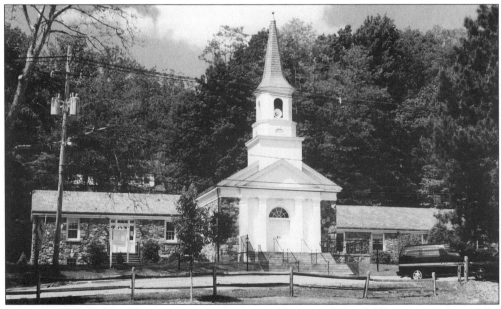

Because of World War II, construction of a new edifice was delayed. The cornerstone of the present stone building was laid in October 1947, and the church, renamed the Brookside Community Church, was dedicated on June 6, 1948. (Author's Archives.)

The Dr. Jesse Upson home is seen at the corner of West Main Street and Cold Hill Road, Brookside, c. 1900. A physician and farmer, he was active in the early history of the township and county.

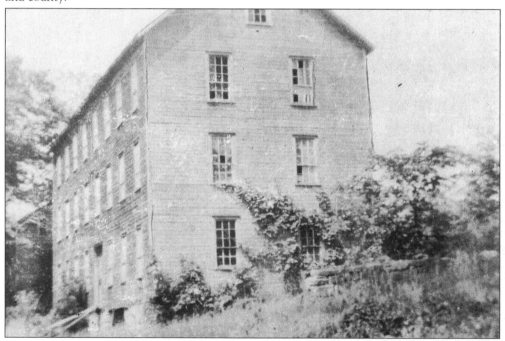

The John and Abraham Byram fulling, weaving, and dying mill on East Main Street, Brookside, built in 1812, was one of several woolen mills in the Mendhams, including another in Brookside, one in Ralston, and one in Union. By 1891, the Byram factory was converted by Adam Brown into a carpet-weaving factory and the fulling mill into a residence. (Township Archives.)

Only one one-and-a-half-story gambrel room house survives, and it is that of Waite Gilbert. It is located at the corner of Tingley Road and East Main Street, Brookside. The old well house still sits in the front yard. (Township Archives.)

Pictured here is the Aaron Losey house in Brookside where he was postmaster in 1868. (Township Archives.)

The two-story Japeth Chedister residence on East Main Street, Brookside is one of the oldest houses in Brookside. The well house still stands in the front yard. (Township Archives.)

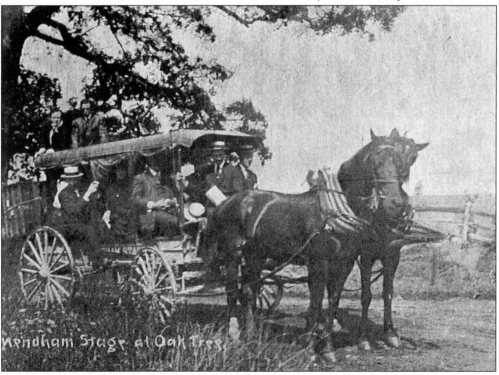

The Mendham—Morristown stage was drawn by a team of horses at the old Oak Tree at Cold Hill and the Mendham-Morristown Roads, c. 1900. Its route often included a stop at Brookside in front of the post office. (Township Archives.)

The Rock-A-Bye Baby Railroad depot on Cherry Lane, Brookside, *c.* 1900, was converted from one of two four-wheel cabooses owned by the railroad. The depot had two railroad sidings, one for a small lumber yard, the other for coal. The Brookside School is in the background. (Township Archives.)

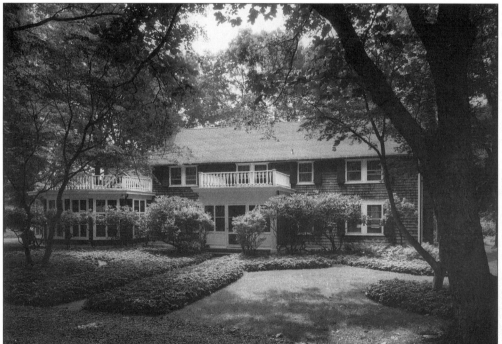

Situated at the end of a maple tree-lined driveway on Route 24, Mendham Township, this two-story center hall farmhouse, the center section of which was originally a barn on Franklin Farms, sits amid 12 rolling acres. It was converted to a residence in the 1920s. (Turpin Realtors.)

Four

THE MANSIONS OF THE "GILDED AGE"

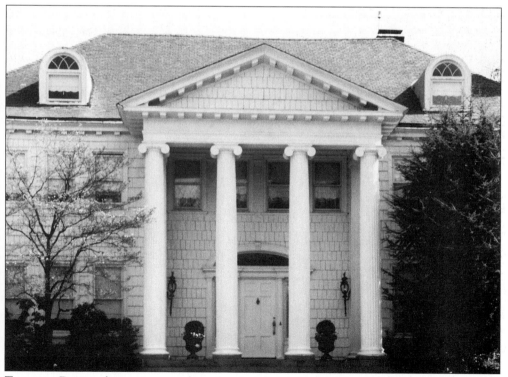

Towering Doric columns are seen here framing the main entrance to White Pillars mansion, built in 1883 for E.T.H. Talmage on the Bernardsville Road. Known then as Woodmere Farms, the mansion was the scene of society fetes at the turn of the century. (Author's Archives.)

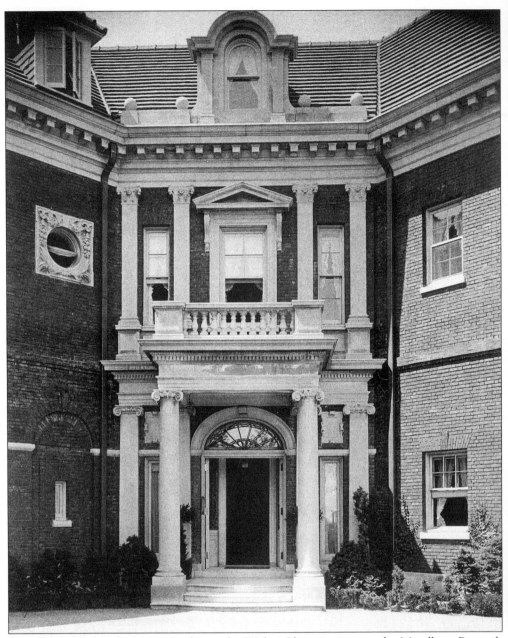

Seen here is the entrance to Wendover, the Walter Bliss mansion on the Mendham Borough slope of Bernardsville Mountain, one of the largest mansions in the Mendhams. In its heyday, the 39-room mansion was the site of lavish parties, dances, and horse events, where the cream of New York, Morristown, and Philadelphia society were entertained. (Roxiticus Golf Club.)

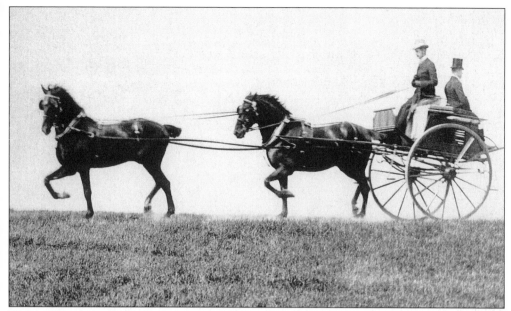

Walter Bliss drives a two-horse team, *c.* 1908, at Wendover, his 422-acre estate on Bliss Road. It included formal and sunken gardens, a race track, tennis courts, the first swimming pool on Bernardsville Mountain (1923), a carriage house, barns, greenhouses, and a gas house to manufacture acetylene gas for lighting. (Roxiticus Golf Club.)

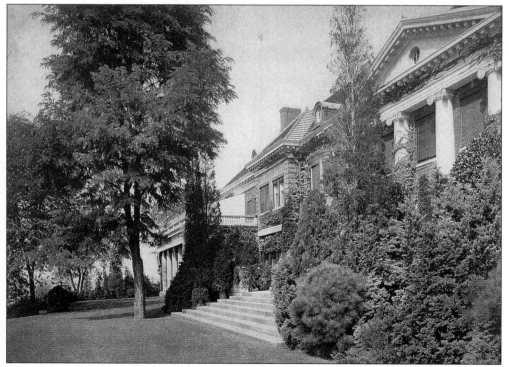

The rear of the Bliss mansion overlooked an extensive lawn, a boxwood garden, several sunken flower gardens, and tennis courts for which Bliss had a wooden floor built so tennis enthusiasts could continue to play through the winter. (Roxiticus Golf Club.)

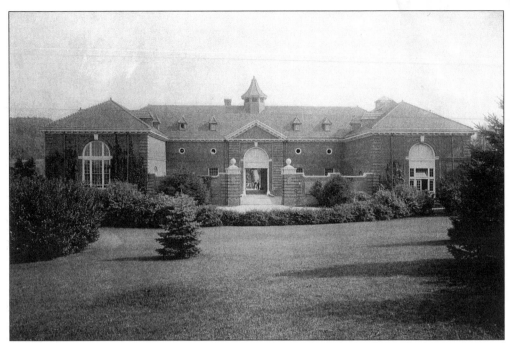

The 22,000 square-foot stable and carriage house at Wendover had a floor which was quartered oak, maintained without a scratch marring its shiny surface. Carriages with iron wheels were moved on four-wheeled dollies fitted with rubber tired wheels to prevent scratches. (Roxiticus Golf Club.)

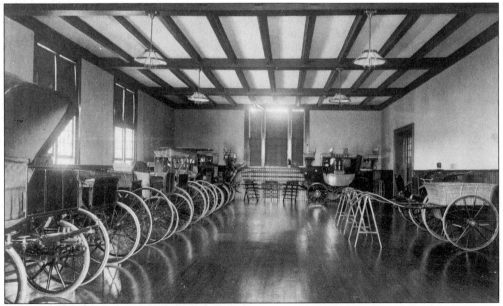

This view is of the carriage room in the carriage house at Wendover. Bliss, a noted horseman, had an impressive collection of horse-drawn equipages, including three coaches that required four horse teams: a Road Coach, a Park Drag, and a Skeleton Brake, the latter one of the few in the United States. (Roxiticus Golf Club.)

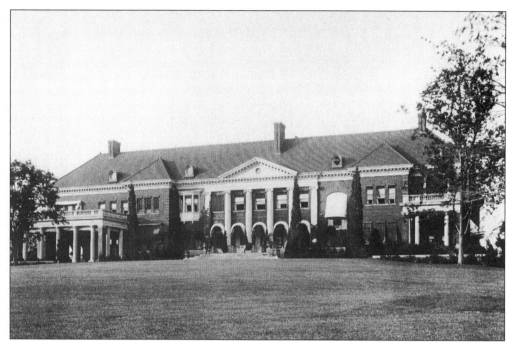

Roman pediments and towering Doric pillars dominate the rear of Wendover, the winding entrance to which once was under a 700-tree grove of Horse Chestnut trees, killed by the Chestnut blight in 1909–10, forcing them to be felled. Sent to the sawmill next to the Union School House, they were made into lumber. (Roxiticus Golf Club.)

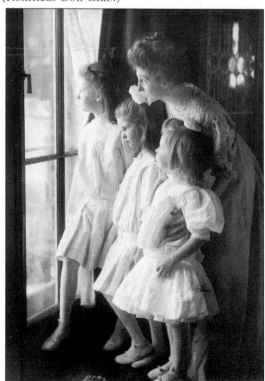

The Bliss children are pictured with their mother, Katherine, *c.* 1912. They are, from left to right: Ruth, Katherine, and Sibyll. (Roxiticus Golf Club.)

Built in 1902 by Bliss, a New York banker who gave up banking to manage his father's large estate, "Wendover" originally comprised the two Ballantine farms. This view is from the front of the mansion, c. 1915. (Roxiticus Golf Club.)

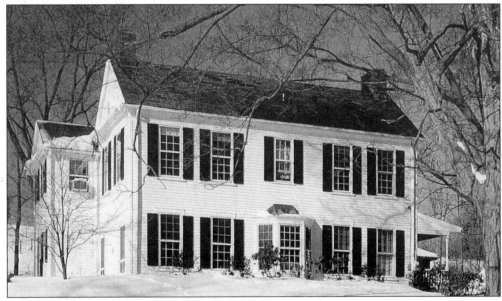

Green Hill Farm at 4 Bernardsville Road, built c. 1860, once was the core of a large estate. It has been owned by men prominent in Mendham's history, including Thompson, Pitney, St. John, and Tiger. With 12 over 12 windows and 10-foot ceilings, it is surrounded by meadows, gardens, and a pond. (Schlott Realtors.)

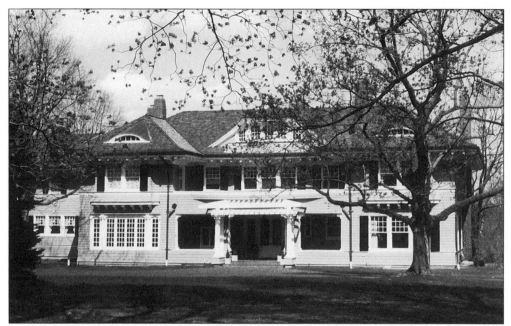

The Dean Sage mansion, built on the Bernardsville Road in 1903 for the Talmage family, was surrounded by gardens and a barn complex which eventually burned. It was later occupied by the Coggeshall family. (Author's Archives.)

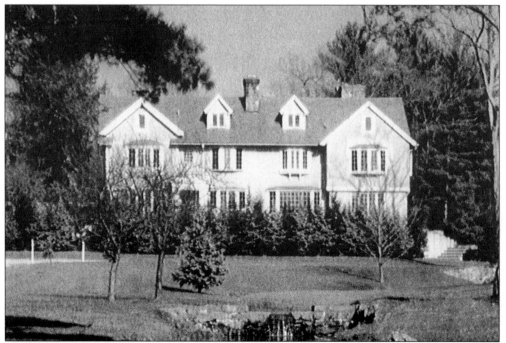

Sandrellan, a reproduction of an English manor house, built c. 1900, was originally a 122-acre estate on Hilltop Road, known for the raising of pure bred Charolaise cattle and its hunter and jumper stables which produced many national champions. (Schlott Realtors.)

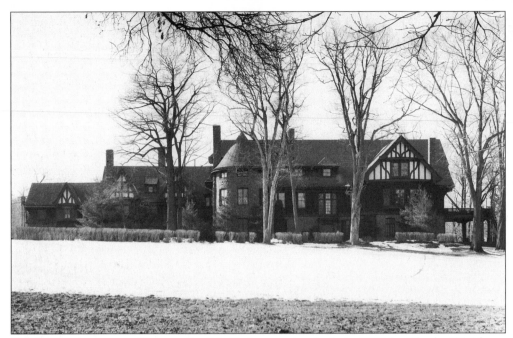

Oakdene, a three-story, 50-room English Tudor mansion built in 1900 for Charles W. Ide on the Bernardsville Road, displays a rich assortment of Gothic Revival elements, towering columns, and leaded bay windows. It has served as a private residence, a school for boys, a church summer camp for children, and a religious counseling center. (Turpin Realtors.)

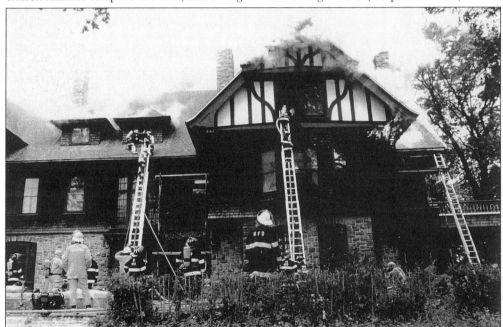

Fire damaged a large portion of Oakdene on July 26, 1991, gutting many rooms and searing the 30 bedrooms, entrance hall, music room, library, kitchens, game rooms, herringbone patterned hardwood floors, and hand-carved wood and plaster trim. It is now being restored. (Ralston Fire Company.)

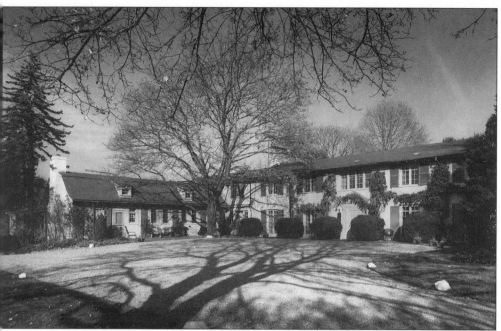

An architecturally unique country mansion, Harmony Hollow is located on a 50-acre estate on Pleasant Valley Road, overlooking Lake Therese, the former National Boy Scout training center now being subdivided. It is a U-shaped two-story mansion. (Turpin Realtors.)

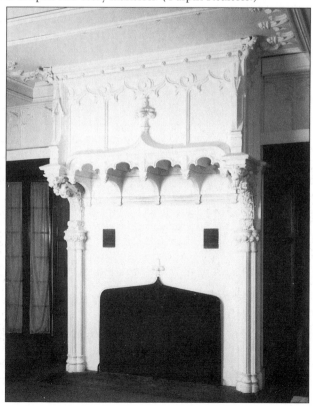

Shown here is the ornate fireplace in the Great Hall at Oakdene. (Turpin Realtors.)

TO LIQUIDATE ESTATE OF
AUDLEY FARMS ESTATES
AUDLEY ESTATES, INC., MENDHAM, N. J.
WILL BE SOLD AT

PUBLIC AUCTION

Comprising 11 Buildings and Acreage with 750 feet Elevation
Residence of 24 Rooms with 4 Car Garage, 2 Family Homes
Model Dairy with Equipment - Private 1 Family Homes
Greenhouse with Cottage and Garage - Farms with Utility Buildings
Acreage - approximately 100 Acre Plots

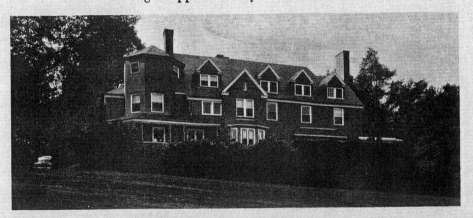

TO BE SOLD IN SEPARATE PARCELS ON THE PREMISES

SATURDAY NOVEMBER 9, 1946 AT 2 P. M

NOW OPEN FOR INSPECTION — LOCATED ON ROUTE 24

Seven miles from Morristown and Five miles from Bernardsville, N. J.

For information and details apply to representative on premises, or
at BLACK HORSE INN, MENDHAM, N. J.

OR TO

James R. Murphy Inc.
217 Broadway, New York 7, N. Y. COrtlandt 7-4642
Member The Real Estate Auctioneers' Association of the City of New York
JOHN J. MURPHY, Auctioneer

This public auction flyer is advertising the subdivision and sale of Audley Farms, the estate of John Talmage, on November 9, 1946. (Author's Archives.)

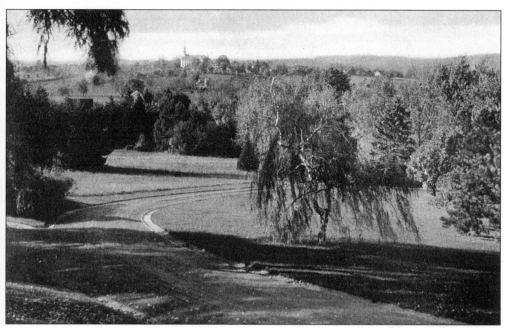

This view from the front porch of Audley Farms overlooks the village of Mendham with the steeple of Hilltop Presbyterian Church visible in the distance, *c*. 1905. (Author's Archives.)

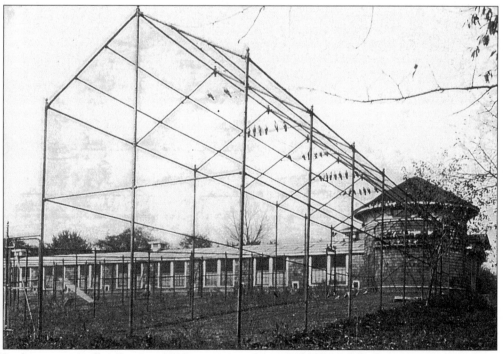

In the rear at Audley Farms *c*. 1905 is a pigeon aviary and house with pheasant runs. (Author's Archives.)

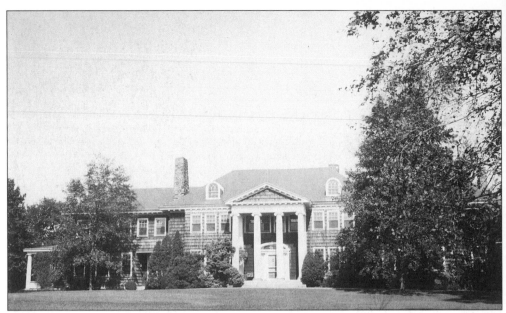

White Pillars is a two-story mansion with towering Doric columns hiding the main entrance, built in 1883 on the Bernardsville Road. It has a unique history, first as the site of parties for society, then as a subdivision into two separate mansions. The top photograph shows the mansion before the wings were removed in the early 1930s and reconstructed at the other end of the estate. (Author's Archives.)

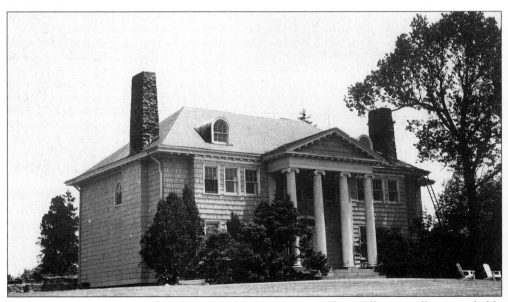

With its two wings removed to form a separate mansion, White Pillars is still a remarkable Colonial-style mansion on the Bernardsville Road. (Author's Archives.)

This image shows the two wings removed from White Pillars and connected to form a separate mansion at the other end of the estate. (Borough Archives.)

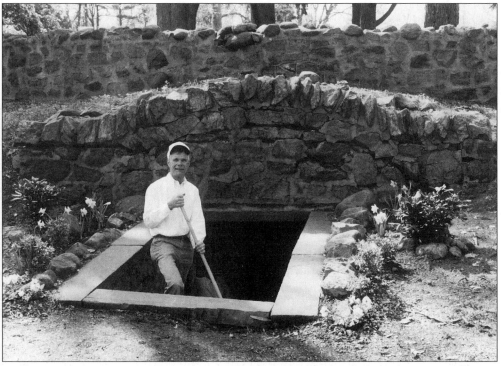

A unique feature at White Pillars was an underground kitchen to feed coachmen who brought guests to society fetes at the turn of the century. Guests would alight at the main entrance, the horses would be taken to the stables, and the coachmen and grooms would descend into the underground kitchen, the entrance to which is shown here. (Author's Archives.)

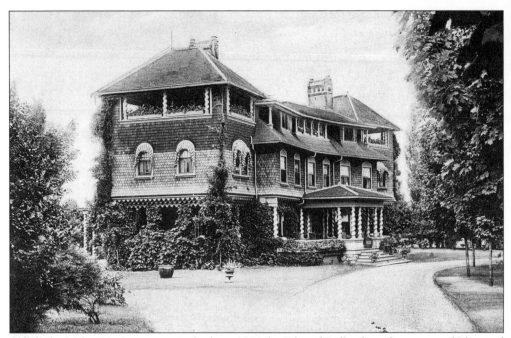

Balbrook, a 15-room mansion, was built in 1891 for Edward Balback at the corner of Bliss and Anderson Roads, Mendham Borough, on a 138-acre estate. A stone embedded in the entrance gate denotes the date of construction. (Ralston Historical Assn.)

Stone Moongate, still standing in the sideyard, was once the center of the formal gardens beside the mansion. The carriage house and farm, connected by a series of roads, stretched across Mine Mount Road, where most of the farm buildings were located, to Pleasant Valley Road. (Author's Archives.)

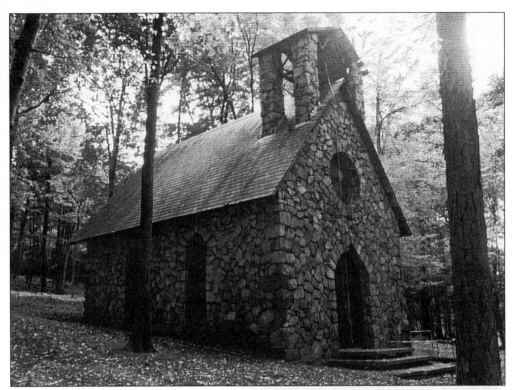

Built in 1908, the Church in the Wild Wood at the Balback estate was a copy of a Bavarian chapel that Mrs. Balback visited and liked. After the Balbacks sold the estate, a cellar was discovered in which there were four burial crypts and a large Italian marble fireplace. (Conti Construction Company.)

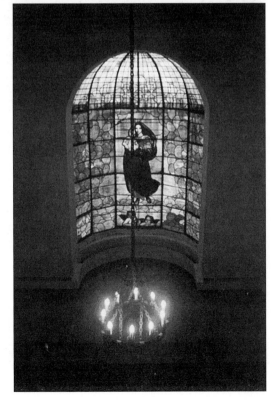

A stained-glass Tiffany window dominates one end of the Church in the Wild Wood. (Conti Construction Company.)

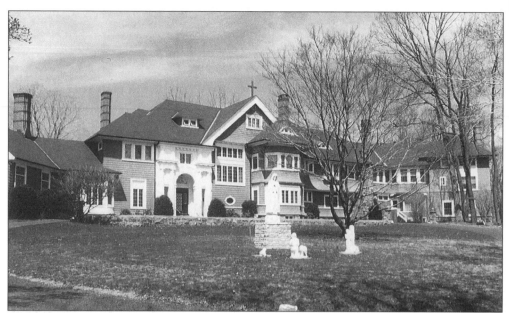

This Georgian-style 47-room mansion was built on a 160-acre estate on the Bernardsville Road by Frederick Cromwell for his son Seymour, killed by a fall from his horse in 1924. Purchased by the Sisters of Christian Charity in 1926, it was named Villa Pauline. (Sisters of Christian Charity.)

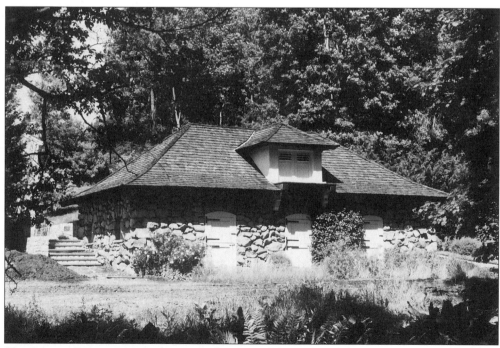

The three-stall stone carriage house on the Cromwell estate, *c.* 1900, is now incorporated in a modern-day mansion complex. (Author's Archives.)

This children's playhouse is seen on Cromwell estate, once located within eight of the main mansions on an estate road to Bernardsville (razed). (Sisters of Christian Charity.)

A farm building complex is shown on Cromwell estate, c.1910. Pictured from left to right are: the chauffeur's cottage, the carriage house, the corn crib (razed), and the farm barns. (Sisters of Christian Charity.)

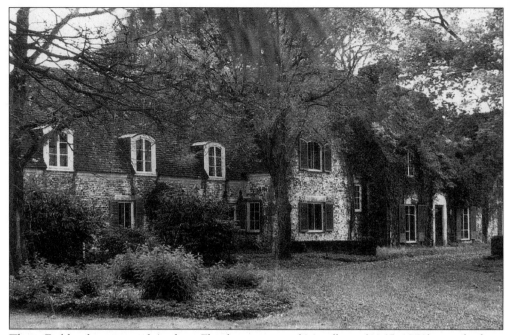

Three Fields, the estate of Andrew Fletcher, mayor of Mendham (1965–1970), was built in 1929 for Benjamin Mosser on Cherry Lane, Mendham Borough. Fletcher left the estate to the borough, which sold it at public auction. (Author's Archives.)

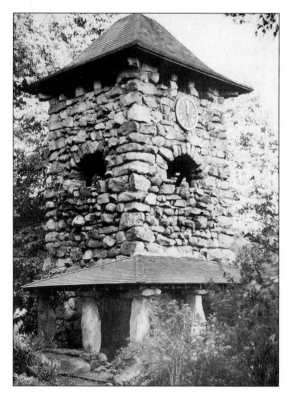

Pictured here is a turn-of-the-century stone clock tower on the Seymour Cromwell estate. It was razed in the 1950s. (Sisters of Christian Charity.)

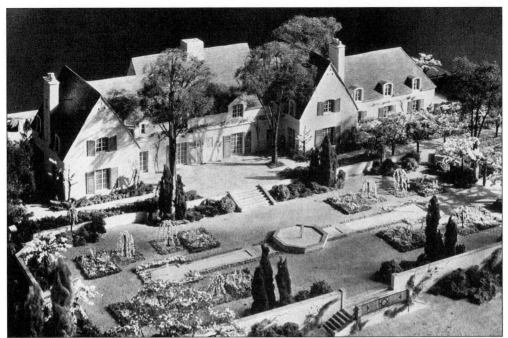

An architect's mock up of Three Fields shows the mansion and gardens prior to construction in 1929. Today the extensive gardens are gone, replaced by a circular driveway and towering trees. (Architecture.)

Shown here is the entrance to the formal gardens at Three Fields, the Andrew Fletcher estate on Cherry Lane, where rare blooms were grown by Fletcher and the estate's builder, Benjamin Mosser. Built of brick, the entrance led to a piazza overlooking the rear gardens. (Author's Archives.)

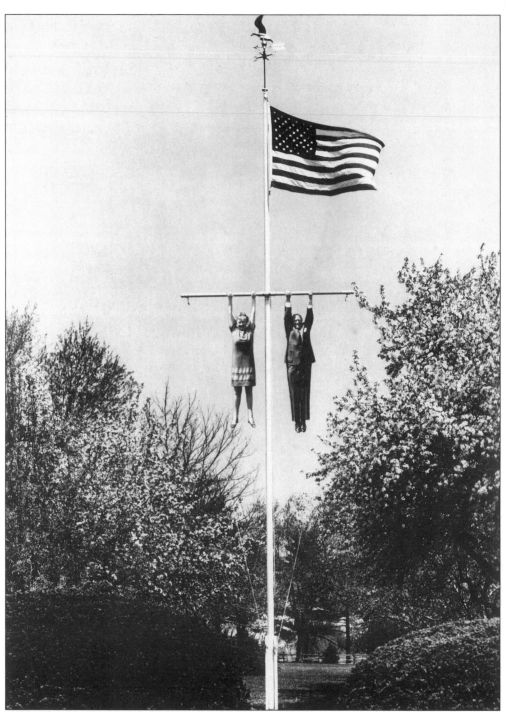

An unidentified couple marks an anniversary by hanging from yardarm of this flagpole, which once stood in front of Three Fields, the Andrew Fletcher estate. The inscription reads: "After fifty years—1968 still hanging together! To the Johnsons—with kindest regards—from the Fletchers." (Borough Archives.)

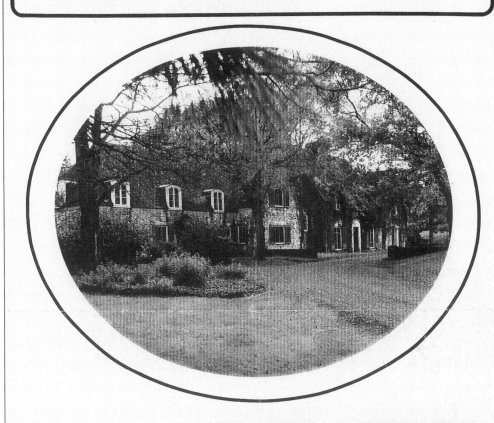

REAL ESTATE PUBLIC AUCTION

ELEGANT ESTATE
48 ACRES
3 PARCELS

ANDREW FLETCHER ESTATE
"Three Fields"
Mendham, New Jersey
48 Acres
to be offered in 3 parcels
1 P.M.,
Saturday, May 15, 1982

A public auction flyer advertises the subdivision and sale of Three Fields, on Saturday, May 15, 1982. (Author's Archives.)

Shown here is a map of Mendham Village center in 1910, four years after the borough was incorporated on May 15, 1906. Main Street (Route 24 today) is the Washington Turnpike, and Hilltop Road is Church Street. Most of the businesses and shops, most long since gone, comprise the Mendham Borough Historic District. (A.M. Mueller Atlas.)

Five

THE VILLAGE
THE CORE OF THE MENDHAMS

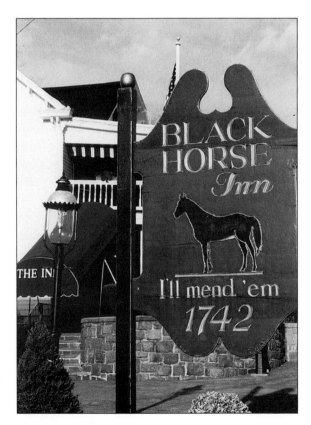

Pictured is the sign for the Black Horse Inn and a converted street gas lamp. The inn is one of eight key buildings in the Mendham Borough Historic District's 140 properties that illustrates the history of the village from its 18th-century beginning to its 1906 incorporation as a borough. (Author's Archives.)

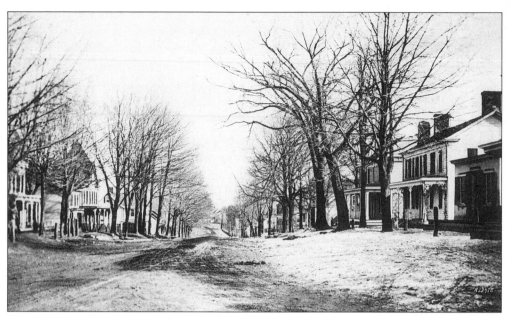

This view is of East Main Street, Mendham Borough, looking towards Morristown, *c.* 1910. (Ralston Historical Assn.)

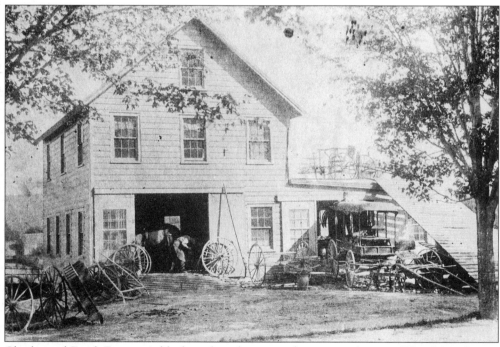

Charles and Frank Freeman's blacksmith and carriage shop is seen here on West Main Street. The ramp to the right was installed to haul carriages to the second floor. In 1908, a garage was added. (Township Archives.)

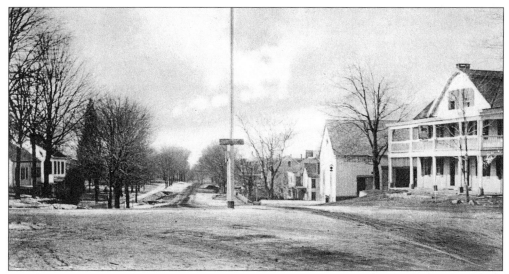

Shown here is West Main Street, Mendham Borough, looking toward Ralston. On the right is the Black Horse Inn and its barns, and in the center of the intersection is the flagpole, the tallest in New Jersey. Struck by lightning in the 1920s, the stump of the pole was used as a base for a traffic light. (Author's Archives.)

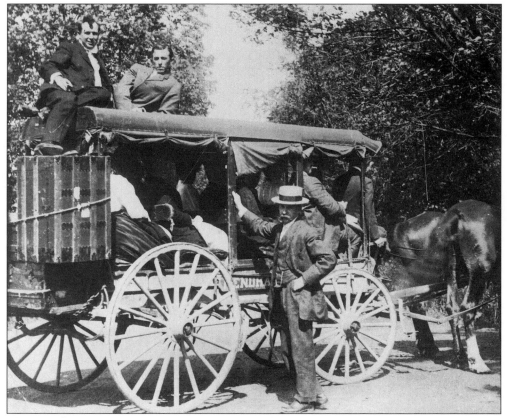

The Mendham-Morristown stage, c. 1895, offered a somewhat rough ride over the main dirt road to Morristown. (Township Archives.)

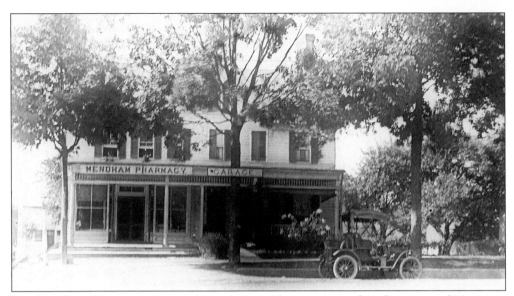

The Mendham Pharmacy, now Robinson's Drug Shop, is pictured at the corner of Mountain Avenue and Route 24. The left side of the building, its original clapboards covered with stucco, was a garage in 1905. The car parked at the curb was one of the first owned by a Mendham resident. (Ralston Historical Assn.)

An unusual structure, the brick building at 7 West Main Street is often referred to as "The Castle." Built in 1909, it is the only 20th-century brick building in the Mendham Borough Historic District. Originally it provided stores on the first floor and apartments on the second floor. The stables of the Black Horse Inn are in the background. (Author's Archives.)

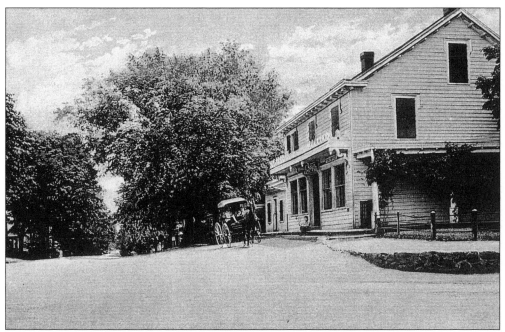

The Mendham Borough Post Office from 1906 to 1977 was located at the corner of Hilltop Road and Main Street on the first floor of a two-story building built in 1904. A carriage stands in front of it in this 1910 photograph. (Ralston Historical Assn.)

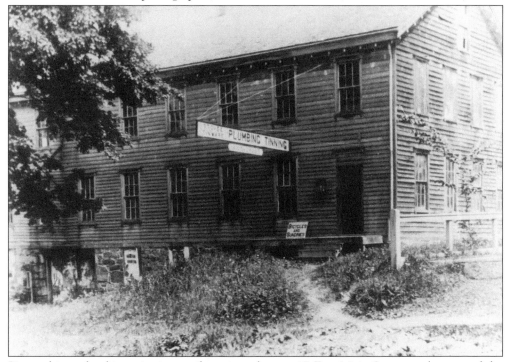

Pictured is a plumbing, tinning, and carriage shop at 17 East Main Street at the turn of the century. The smaller sign reads "Bicycles and sundraes." The site is now the location of the Peapack Gladstone Bank. (Morristown Library.)

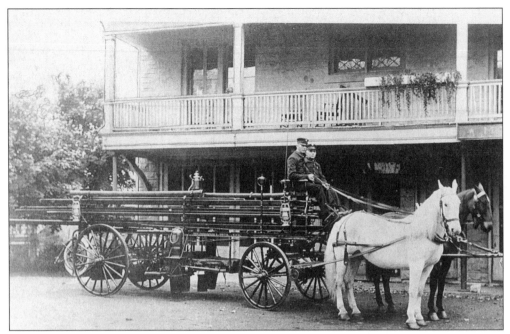

Pictured here is the horse-drawn Mendham Hook & Ladder Company apparatus in front of the firehouse at 21 West Main Street. The horses are "Prince" and "Brownie," and the driver is James C. Menagh. (Mendham Fire Department.)

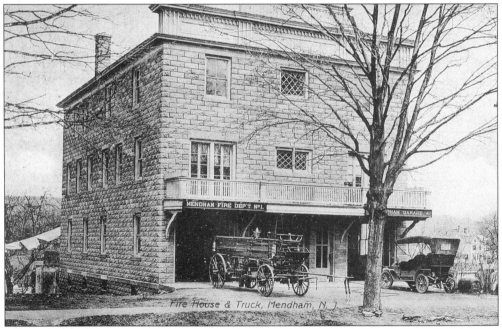

The Mendham Borough Fire Department's first real firehouse is now the Wichert Real Estate Agency building at 21 West Main Street. The sign in the photograph reads "Mendham Fire Department No. 1." The other half of the building was a garage in front of which a car is parked. The building included apartments on the second floor and a dance hall on the third floor. (Ralston Historical Assn.)

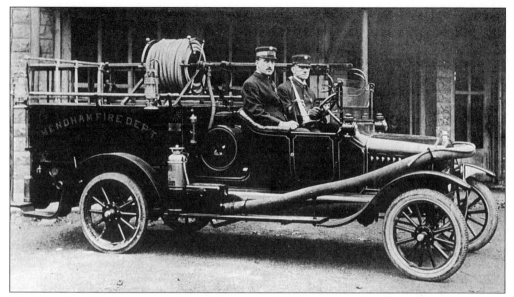

The Mendham Fire Department's Ford Pumper in 1919 was one of the first pieces of motorized apparatuses the firemen acquired by raising funds themselves. Eric Zeliff is the driver and Frank Groenkyke is the the chief. (Mendham Fire Department.)

The old fire alarm engine rail is shown at the entrance to the Mendham Borough Fire Department on East Main Street. It dates to 1906, when two were purchased to sound an alarm by pounding on the metal ring with a hammer. The other was in front of the Freeman Building on West Main Street. Later, the bell at Hilltop Presbyterian Church was used to sound fire alarms. (Author's Archives.)

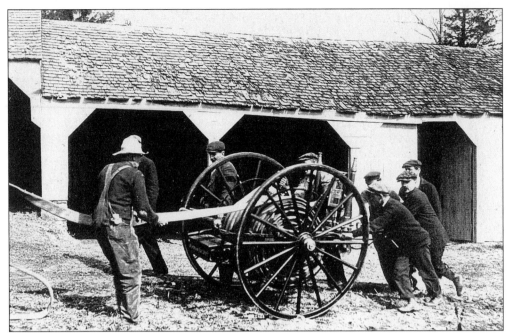

Mendham Borough firemen practice a hose cart drill to test water pressure, which was sufficient to reach halfway up the steeple of Hilltop Presbyterian Church in 1909. The church's old horse stalls on Talmage Road are seen in the background. (Mendham Fire Department.)

The Mendham Fire Department reconstructed the old Mendham Methodist Church on East Main Street for use as a firehouse in 1948, when the borough government vacated it, moving to the Bowers Building on West Main Street. Note the alarm rail at the right. (Author's Archives.)

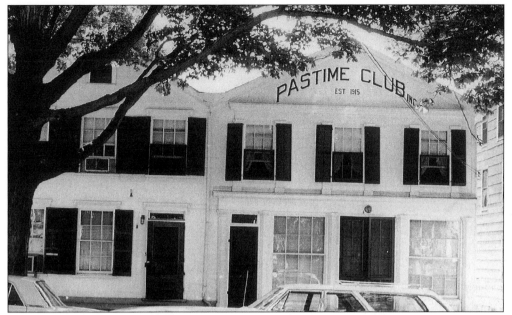

The Pastime Club was established in 1915 to promote and encourage athletic achievement by the borough's youth. In 1941, the club purchased the Anna Boyd building, built in the 1840s by Aaron Hudson for his son-in-law's dry goods business. In 1953 they added a building containing four bowling alleys. (Pastime Club.)

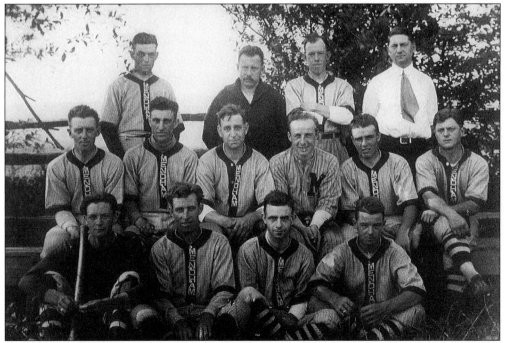

Pictured here is the Pastime Club baseball team, c. 1910. Its members, managers, and coaches are unidentified. The team played those of neighboring communities, including Chester, Bernardsville, and Basking Ridge. (Pastime Club)

CIRCULAR

OF THE

Mendham Female Seminary.

Miss M. M. LEDDELL, Principal.

MAPLE LAWN,

MENDHAM, MORRIS Co., NEW JERSEY.

1876.

"The Jerseyman" Print, Morristown, N. J.

This cover of an 1876 circular advertises the Mendham Female Seminary, one of more than four private educational institutions founded in Mendham in the late 1800s and early 1900s. It offered primary, academic, and collegiate courses. Tuition for boarding students was $350 a year, and day pupil tuition ranged from $12.50 for English branches to $6 for primary. (Sally Foy.)

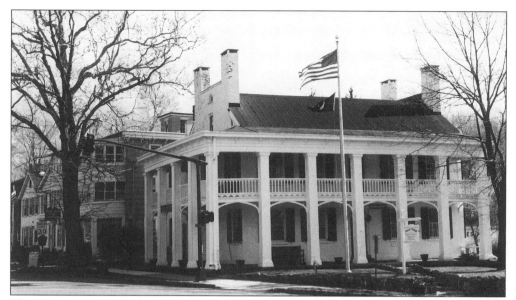

The Phoenix House built 1801–1805 at the crossroads in Mendham center has been a young ladies seminary, an inn, tea room, antique shop, and, since 1960, a municipal building. The upper porch and columns were designed and added by Aaron Hudson, *c.* 1830. It is listed in the Library of Congress as "possessing exceptional historic and architectural interest and being worthy of preservation." (Author's Archives.)

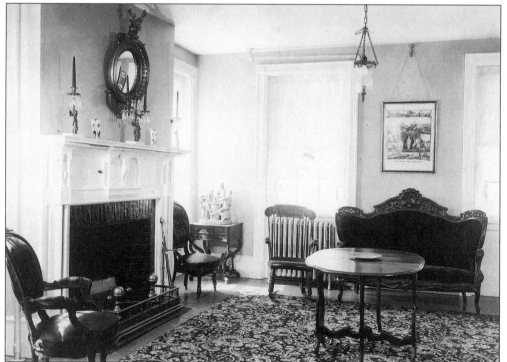

The northwest parlor of the two-and-a-half-story Federal-style Phoenix House, *c.* 1910, was furnished with Victorian furniture and a single gas light bulb for illumination. (Borough Archives.)

The Phoenix family is pictured in a car beside the Phoenix House. Caroline E. Phoenix is driving. In the front seat are her daughter Elizabeth, and Vincent Banks. Her son Roderic, Elizabeth Sullivan, and an unidentified youth are in the rear seat. (Mendham Borough Library Archives.)

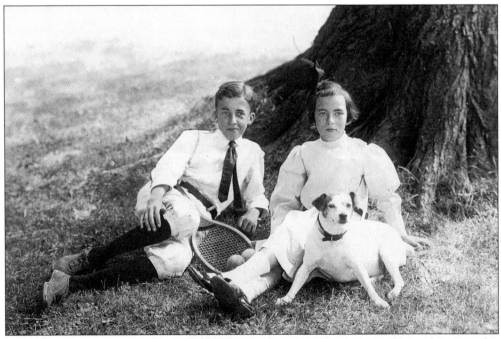

Elizabeth Phoenix and her brother Roderic are shown on the lawn in front of St. Joseph's Church after a game of tennis, c. 1910. (Mendham Borough Library Archives.)

This is a photograph of the Methodist Church, which was moved to the entrance of the present fire department on East Main Street while being painted. It was purchased in 1891 and moved by the Township of Mendham for a Township Hall. (Township Archives.)

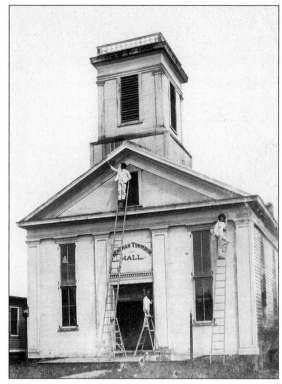

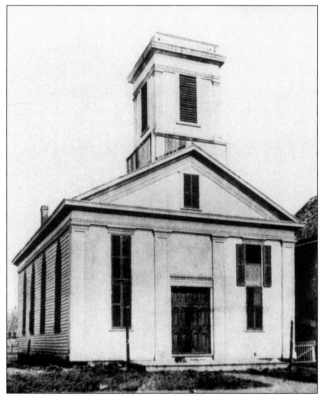

When the Borough of Mendham incorporated in 1906, it took over the Township Hall for its municipal building, one of many uses the building has had. (Borough Archives.)

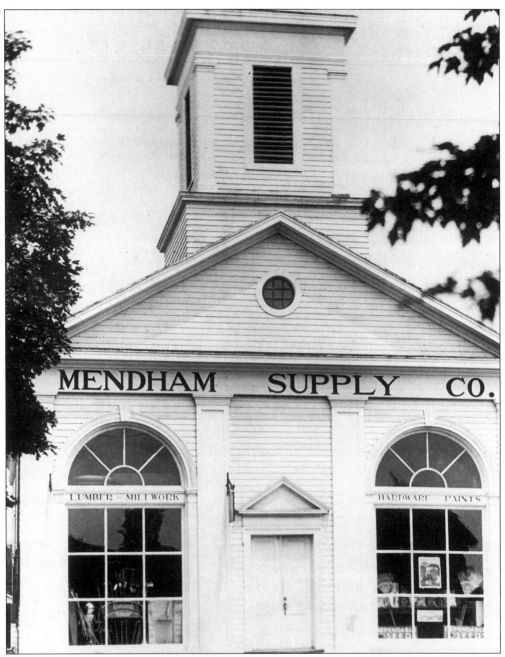

Pictured is the old Methodist church as the Mendham Supply Company, a lumber, millwork, and hardware store. Earlier, in the late 1890s, it served as the Mendham Opera House. It is now a recreation hall at the new firehouse. It had so many uses that it appeared in Ripley's "Believe It Or Not." (Borough Archives.)

Shown here is the program for three operas presented at the Mendham Opera House on November 22, 1895, for the benefit of the Ladies' Aid Society. Included were, *Out In The Streets*, *The Mischievous Negro*, and *The Harvest Drill*. (Mendham Historical Society.)

The Hilltop Presbyterian Church manse, the center core of which was built in 1832, is pictured here. The two wings were added in the 1920s and a church school at the rear was added in 1958. It is now used as a church office. (Sally Foy.)

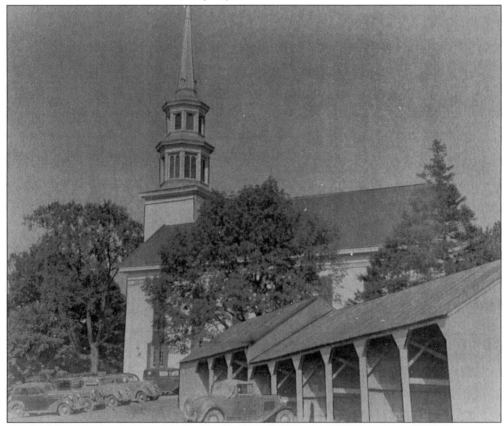

The horse stalls on Talmage Road beside the Hilltop Presbyterian Church were used by parishioners for their horses during services, which at the turn of the century sometimes lasted all day Sunday. The stalls were razed in the 1940s. (Presbyterian Church.)

Two Hundreth Anniversary

of the

Presbyterian Church

Mendham, New Jersey

September 15th to 18th, 1938

Hugh Watson Kendall, M. A.
Minister

Shown here is an announcement of the 200th anniversary celebration of Hilltop Presbyterian Church, September 15 to 18, 1938. (Presbyterian Church.)

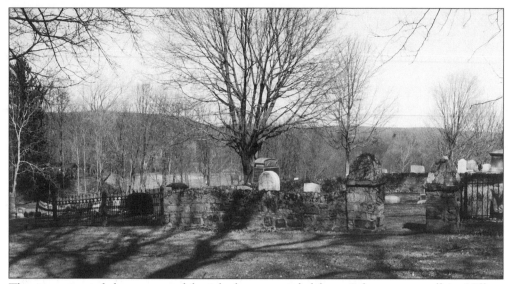

This is a view of the segregated burial plot surrounded by a 3-foot stone wall in Hilltop Presbyterian Church Cemetery. This was where William Phoenix was buried when trustees refused to allow his internment in the cemetery because he sold liquor. (Author's Archives.)

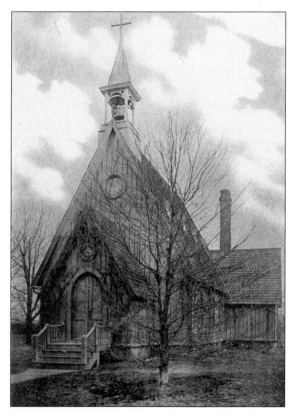

Built on property donated to the church in 1886 by John Van Vost, St. Mark's Episcopal Church on West Main Street was originally a summer chapel from 1881 to 1886. The plans used for Grace Church in Jersey City (razed) were the same ones used 50 years later for St. Mark's edifice. (Sally Foy.)

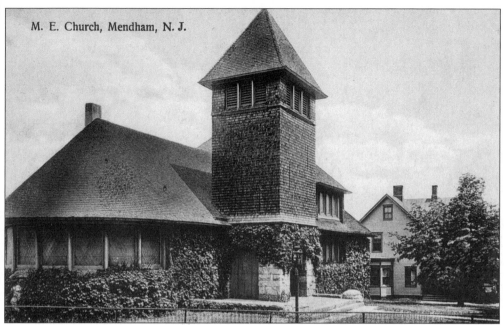

M. E. Church, Mendham, N. J.

The present Methodist Church, succeeding the smaller frame edifice that became the Township Hall in 1891, was built on the same site on East Main Street in 1893. The field stone from which the church was built was hauled on sledges from a quarry on the William Bedell farm by church members during that winter. Aaron Hudson was the builder. (Author's Archives.)

Fueled by the issue of slavery, 35 members of Hilltop Presbyterian Church formed the second Presbyterian church in 1860. The church they built on Hilltop Road served until 1904, when the congregations were reunited and the second church torn down, its wood and windows being used in many local homes. The Bailey Funeral Home is built on the foundation of the razed church. (Township Archives.)

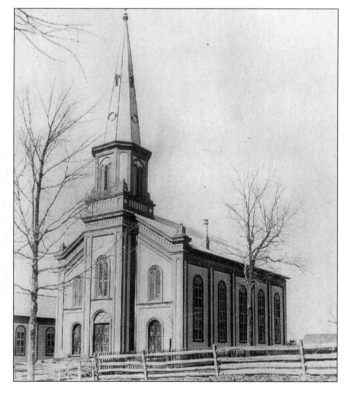

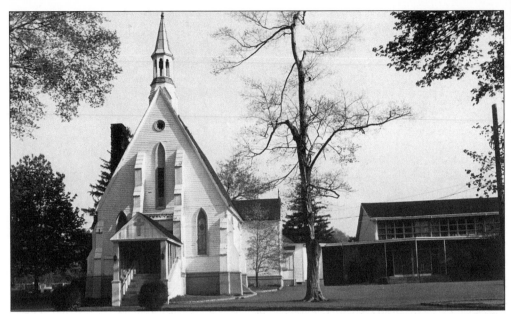

Built in 1860 on West Main Street, St. Joseph's Roman Catholic Church was originally a mission church guided by the Church of the Assumption in Morristown. Built by Aaron Hudson, the Gothic-style edifice with a steeply pitched gable roof, small wooden buttresses, and pointed arch openings, originally had narrow clapboard siding, since covered with aluminum siding. In 1962 a school wing was added. (St. Joseph's Church.)

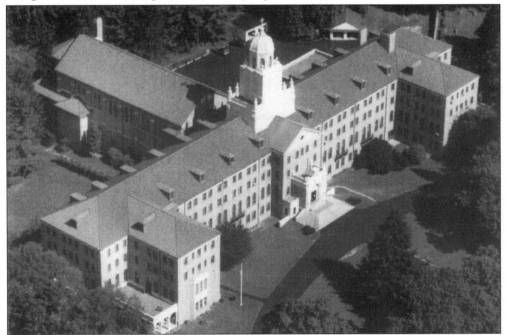

Pictured here is an aerial view of the Mallinckrodt Convent of the Sisters of Christian Charity on the Bernardsville Road, founded on the 112-acre Seymour Cromwell estate in 1926. A Roman Catholic sisterhood, its members are dedicated to the education of youth on three continents. (Sisters of Christian Charity.)

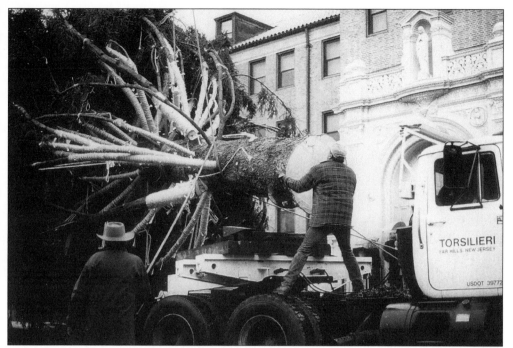

Workmen load a huge Christmas tree, cut at the Mallinckrodt Convent on the Bernardsville Road, for its trip to New York where it would be used as the 1995 Yule tree at Rockefeller Center. (Sisters of Christian Charity.)

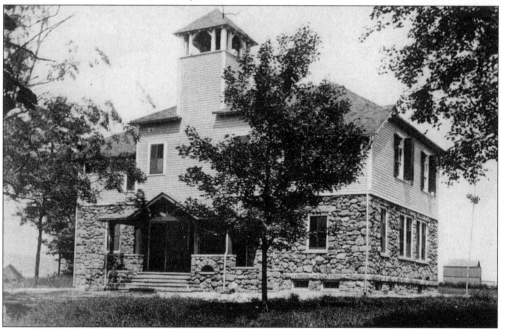

In 1904 the one-story frame school on Hilltop Road in front of the present school was renovated by raising the original first floor to a second floor and building a new first floor of field stone, as viewed in this 1917 image. It served until the present school was built in 1929. (Ralston Historical Assn.)

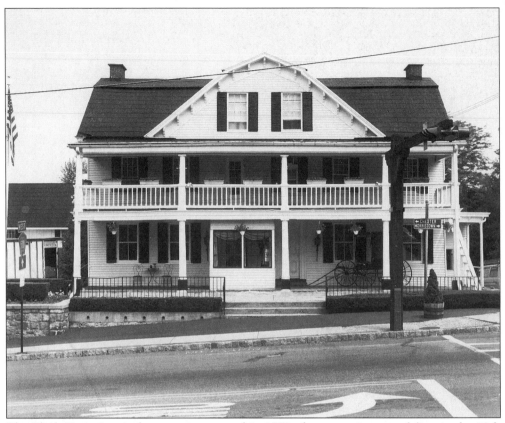

The Black Horse Inn is shown as it appeared in 1923 after extensive remodeling in the 19th century. The two-and-a-half-story inn originally had paired front doors, one leading to the hotel, the other directly into the bar. The tap room door was removed in 1983 when the porch was enclosed. (Black Horse Inn.)

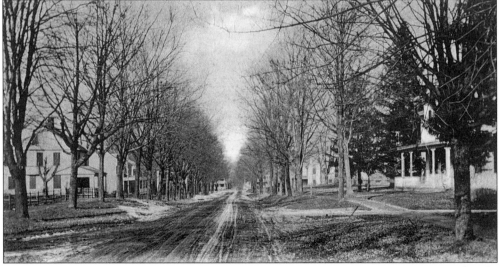

This view is of Church Street, now Hilltop Road, looking toward Hilltop Presbyterian Church. In this 1906 image it was a dirt road bordered by trees and a dirt sidewalk. (Author's Archives.)

Built by Aaron Hudson, the Bowers Building, named in honor of Dr. F. Clyde Bowers, Mendhams mayor (1947–1950), originally consisted only of an entrance hall, front parlor with a bedroom above, and a lean-to kitchen. Located adjacent to the Phoenix House, it is now the borough public works building. (Author's Archives.)

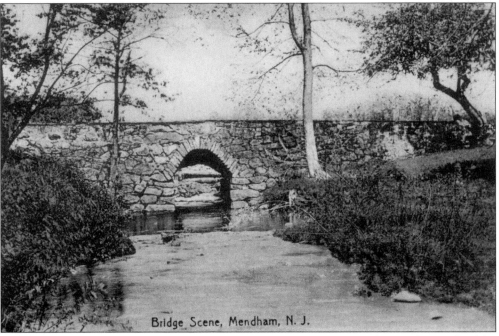

Bridge Scene, Mendham, N. J.

Pictured here is the stone arch bridge carrying Mountain Avenue over the North Branch of the Raritan River, c. 1928. (Wilma Sagurton.)

REUNION

April 24th, 1937

Babbitt Select School

1881—1901

MENDHAM, N. J.

TEACHERS: Miss Leila Babbitt

Miss Mary Babbitt

This was the program for the reunion of the Babbitt Select School on April 24, 1937. The school, incorporated in the kitchen of its two teachers, Misses Leila and Mary Babbitt, had a total of 176 pupils from 1884 to 1901, 44 of whom were deceased at the time of the reunion. (Sally Foy.)

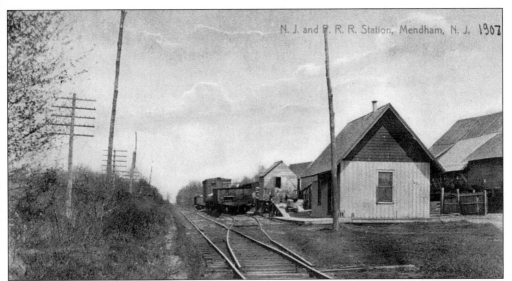

Pictured above is the Mendham depot of the Rock-A-Bye Baby Railroad, c. 1907, on lower Mountain Avenue. The freight siding was a busy place. One contractor said construction of the Walter Bliss mansion gave him his start in the Mendham area, as he spent two years hauling bricks to the estate from the Mendham depot. (Ralston Historical Assn.)

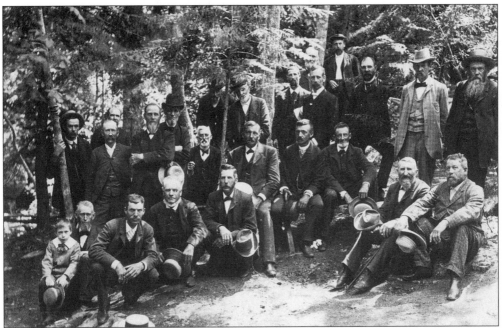

Pictured here are the first riders on the Rock-A-Bye Baby Railroad on June 17, 1981. Among the riders pictured are: Theodore S., Peter F., Tunis Hill, Mahlon Cole, Marius Robinson, Eugene Babbitt, James Burd, Theodore Quimby, Edwin Sanford, Dan Sutton, John Lindsley, Bryant Bowman, William Phoenix Sr., George Aldridge, Theodore Blazure, Stephen Babbitt, David Thompson, Peter Garabrant, Ben Losey, John DeMott, conductor (with beard), Rev. Kane (Methodist Church), Tunison Melick, Robert Garabrant, and Roy Somers. (Mendham Historical Society.)

The barn and paint shop behind the Wilder House at 6 Hilltop Road were repaired and rehabilitated in 1970 into three specialty shops in what is called "The Alley." (Joel S. Carlbon.)

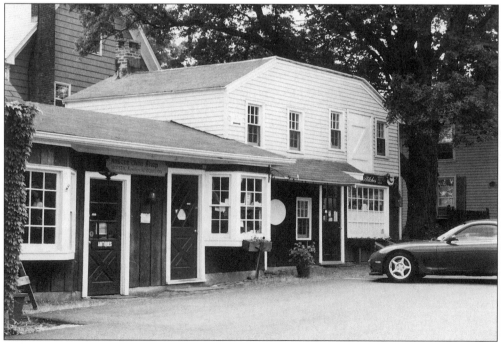

Pictured is the Wilder barn and paint shop converted into specialty shops as they appear today. (Author's Archives.)

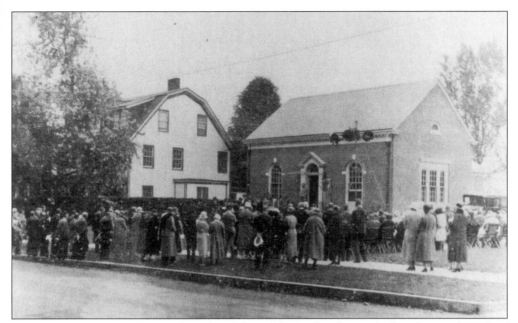

The Mendham Library designed in the Colonial Revival style was built in 1932, the gift of Louise Forysthe Demarest. It was originally a small one-room brick building. An addition in 1976 more than doubled its size. Here crowds attend the 1932 opening. (Morristown Library.)

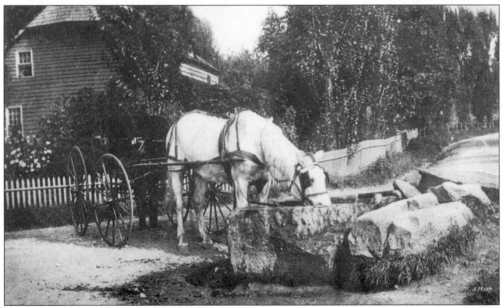

A horse drinks from one of two water troughs at the corner of Bernardsville and Pleasant Valley Roads. (Morristown Library.)

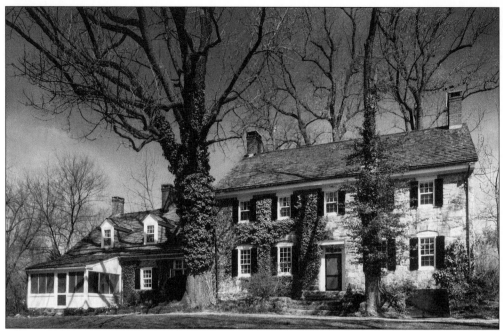

Built in 1765, the David Thompson house at 56 West Main Street originally faced south on the road to Philadelphia. Built of field stone by John Carey, master mason, for his son-in-law, a Revolutionary War officer and organizer of the Mendham Company of Minutemen, the house has been extensively renovated and expanded. (Turpin Realtors.)

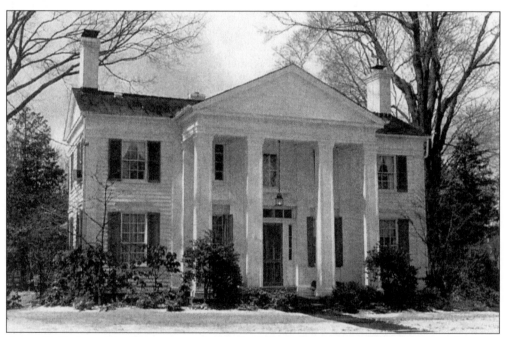

Aaron D. Hudson, Mendhams master builder/architect, designed and built a two-story home in the Greek Revival style for himself in 1840 on Hilltop Road. Towering columns support the portico entrance. Behind the house was a carpenter shop. (Author's Archives.)

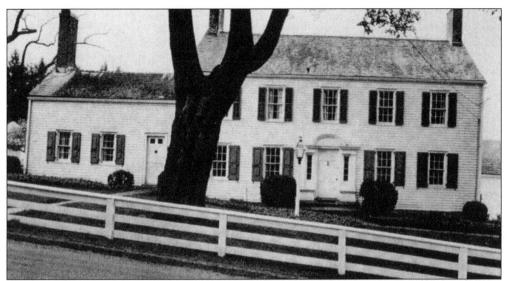

Built *c.* 1740, this two-story house with a wing at the corner of Talmage Road and Corey Lane, was the home of Dr. Ebenezer Blachley, one of the founders of the New Jersey Medical Society, who married a sister of Tempe Wick. In the early 1900s it was part of Audley Farms, the John F. Talmage estate. (Turpin Realtors.)

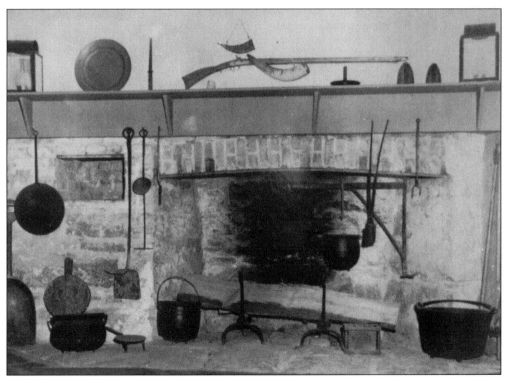

Purchased in 1947 by Sidney K. Doggett, the house has been carefully restored to its original condition. Pictured here is the restored original fireplace in the basement of the house. (Township Archives.)

Described as a mid-19th-century villa, the two-and-a-half-story James Cole house at 34 East Main Street has many features of the Italianate style, ranging from its gabled facade and pedimented windows to the bracketed eves. (Schlott Realtors.)

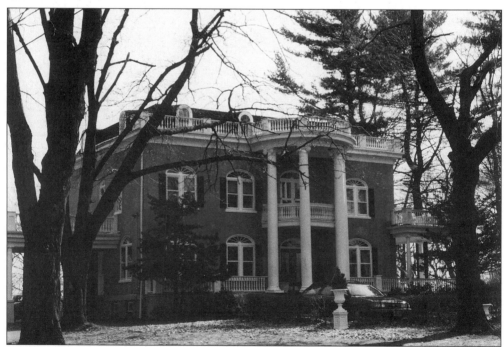

The Dr. George DeGroot house, a two-and-a-half-story Colonial Revival-style house at 14 Prospect Street built in 1812, is the most ornate of Mendham's Victorian houses. With towering Ionic pillars supporting a balcony at the central bay of the second floor, it has Baroque "cartouches" applied to the facade wall and a slate roof. (Author's Archives.)

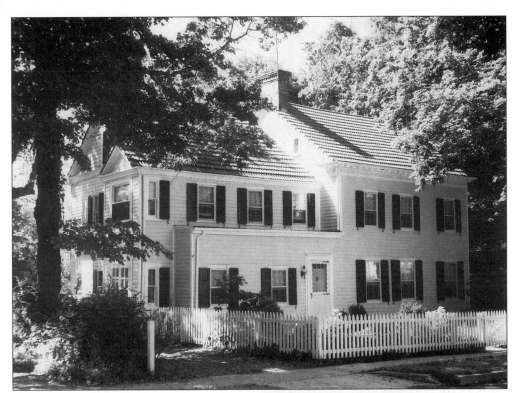

The residence at 7 Hilltop Road, once stores and now converted into offices, was built in the early 19th century as a Dutch Colonial with the kitchen in the rear of the 15-room house. At one time a tunnel ran from its basement under Hilltop Road to the site of the Bailey Funeral Home. (Turpin Realtors.)

This wooden cigar store Indian was nicknamed "Mr. How" and stood in front of Robert Stones Antique Accents store on Hilltop Road for many years. He wore a sign over his arm indicating the store was open or closed. (Wilma Sagurton.)

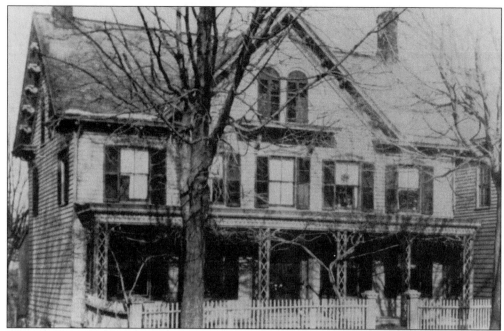

The Marsh-Brotherton house at 4 East Main Street, built before 1868, once had a wide front porch and wooden fence surrounding its small front yard. Similar to the Robinson Drug Shop building, it has a cross gable with round arched windows and scroll brackets under the eves. Joined to number 6 East Main Street, it is now the office of Burgdorff Realtors. (Morristown Library.)

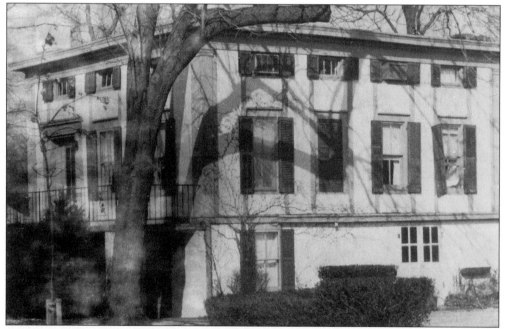

The Nicholas house, built by Aaron Hudson in 1842 on New Street, is similar to the Russell Carter residence in Ralston, also built by Hudson. Both dwellings were inspired by villas in France and have hipped roofs with a cupola to light a hallway. (Township Archives.)

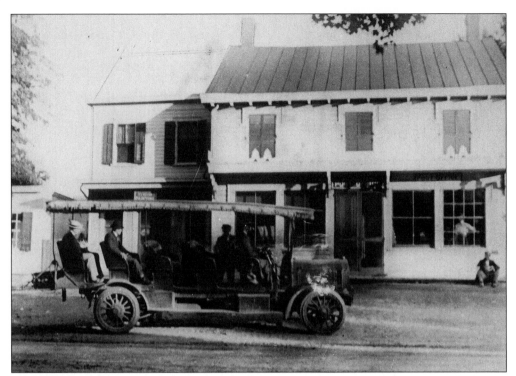

The first motor bus, a crude open-sided affair, started operation between Mendham and Morristown over the bumpy road that existed until the Washington Turnpike (now Route 24) was completed prior to 1910. (Township Archives.)

It was not until the Mendham Garage Company started a regularly scheduled service in 1924 between Chester, Ralston, Mendham, Brookside, and Morristown, with train connections at the Lackawanna Railroad station in Morristown, that a dependable service was achieved. Adhering to a time table that provided Mendham with hourly service, it also had low fares: Brookside, 25¢, Mendham, 35¢, Ralston, 50¢, and Chester, 60¢. (Don & Newly Preziosi.)

TIME TABLE

R—Request
†—Saturday only.

LEAVE Chester	Ralston	WEEK-DAYS Mendham	Brookside	ARRIVE Morristown	Trains Con.
		7:05 A. M.	7:10 A. M.	7:35 A. M.	7:40 A.
7:45 A. M.	7:55 A M.	8:00 A. M.	8:00 A. M.	8:30 A. M.	8:34 A
		9:40 A. M.		10:10 A. M.	10:31 A.
		†1025 A. M.	R-10:30 A. M.	†10:50 A. M.	10:46 A.
12:00 A. M.	12:10 A. M.	12:20 A. M.		12:40 M.	12:45 P. M
		1:20 P. M.	1:20 P M.	1:50 P. M.	1:57 P.
		†1:55 P. M.		†2:25 P. M.	
	3:30 P. M.	3:40 P. M.	3:50 P. M.	4:15 P. M.	4:17 P.
		4:20 P. M.		4:50 P. M.	5:05 P.
5:10 P. M.	5:20 P. M.	5:30 P. M.		6:00 P. M.	6:05 P.
		†6:45 P. M.	†6:50 P. M.	†7:15 P. M.	†7:22 P.
7:00	†7:10 P. M.	†7:15 P. M.		†7:35 P. M.	

D. L. & W. Sta.	U. S. Hotel	Brookside	Mendham	Ralston	Chester
			7:25 A. M.	7:30 A. M.	7:40 A.
			9:20 A. M.		
8:44 A. M.	8:50 A. M.	9:40 A. M.	9:55 A. M.	10:10 A. M.	
9:12 A. M.	9:15 A. M.				
10:21 A. M.	11:00 A. M.	11:20 A. M.	11:30 A. M.	11:35 A. M.	11:45 A. M
†12:08 P. M.	†12:30 P. M.		†12:55 P. M.		
1:23 P. M.	1:30 P. M.	1:50 P. M.	2:00 P. M.		
†2:38 P. M.	†2:40 P. M.	†3:05 P. M.	†3:15 P. M.		
3:30 P. M.	3:35 P. M.	3:50 P. M.	4:00 P. M.	4:05 P. M.	4:15 P.
5:02 P. M.	5:05 P. M.		5:25 P. M.		
5:12 P. M.	5:30 P. M.	5:55 P. M.	6:05 P. M.	6:10 P. M.	
6:19 P. M.	6:20 P. M.	6:45 P. M.	6:55 P. M.	7:05 P. M.	7:15 P.
	†9:30 P. M.	†9:50 P. M.	†10:00 P. M.		
	†11:00 P. M.		†11:25 P. M.	11:35 P. M.	11:55 P. M.

		SUNDAYS			Trains Con.
Chester	Ralston	Mendham	Brookside	Morristown	
		8:30 A. M.	R-8:35 A. M.	9:00 A. M.	9:07 A. M.
9:30 A. M.	9:40 A. M.	10:05 A. M.		10:30 A. M.	10:46 A. M.
		4:30 P. M.	4:35 P. M.	5:00 P. M.	5:15 P. M.
6:20 P. M.	6:30 P. M.	6:40 P. M.	R-6:45 P. M.	7:05 P. M.	7:20 P. M.

D. L. & W. Sta.	U. S. Hotel	Brookside	Mendham	Ralston	Chester
9:38 A. M.	9:40 A. M.	10:00 A. M.	10:05 A. M.		
11:02 A. M.	11:05 A. M.		11:35 A. M.	11:50 A. M.	12:05 P. M.
5:35 P. M.	5:40 P. M.		6:05 P. M.	6:10 P. M.	6:20 P. M.
8:03 P. M.	8:05 P. M.	8:25 P. M.	8:35 P. M.	8:40 P. M.	8:55 P. M.

| FARES | BROOKSIDE 25 | | MENDHAM 35 | | RALSTON 50 | CHESTER |

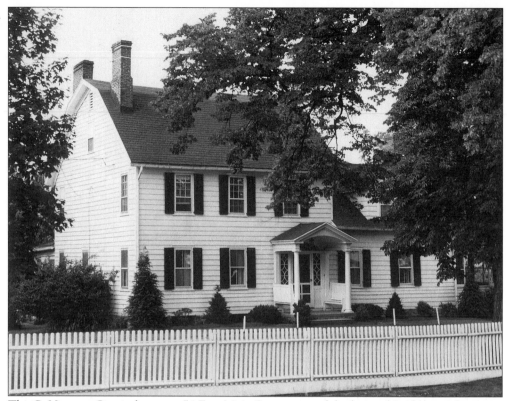

The C. Vincent Guerin house at 54 East Main Street, one of the borough's older residences, is a frame clapboard house with a single wing. (Township Archives.)

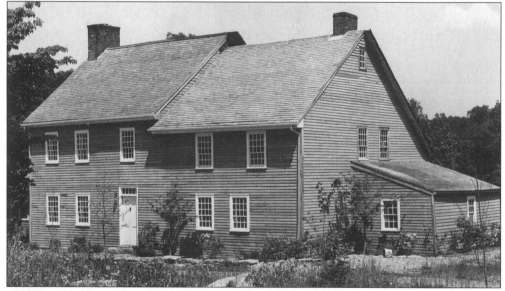

The Pariser house at 146 Mendham Road has been restored as a typical 18th-century house by Mr. and Mrs. Burton Fraser, after the house was moved across the fields from West Main Street. The old kitchen and the room above it were restored without plastered walls and ceilings and the windows with thin sash and wide muntins. (Township Archives.)

Six

WASHINGTON VALLEY

ITS MANSIONS AND FARMS

Shown here is the Washington Valley Historic District marker. The 1,883 acres that comprise the district include 92 properties, including three previously on the National Register of Historic Places. Fifty-three percent of the valley, which had ten great estates, seven of which survive, is untouched rural landscape. (Author's Archives.)

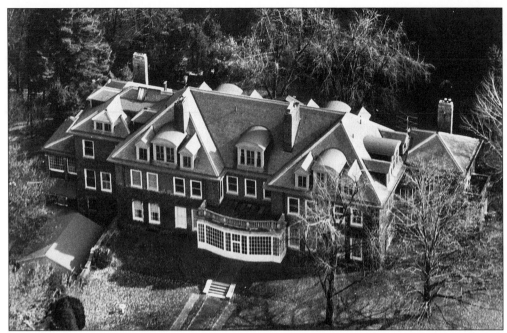

Wheatsheaf, the mansion of Gustav E. Kissel, was built in 1905 on Kahdena Road. Kissel's wife was a Vanderbilt, and he was a New York banker. It was on a polo field here that Morris County's first polo match was played in 1890. (Author's Archives.)

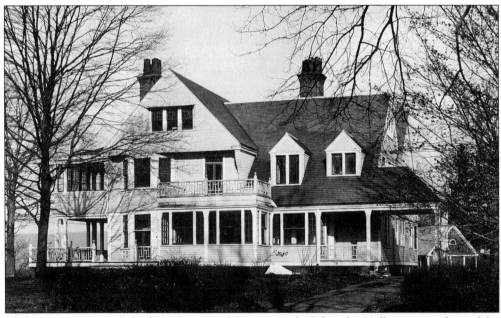

This frame mansion was built at the turn of the century by Edward J. Hall, vice president of the American Telephone & Telegraph Company, on Kahdena Road on what became known as "Telephone Hill" because of the number of telephone tycoons who built mansions there. (Author's Archives.)

NOTICE

The N. J. & Penna. R. R. will run a Special Train from Pitney to White House, on

SEPTEMBER 22, '10

to connect with the Special Train on C. R. R. for ALLENTOWN FAIR

			TIME	FARE
Pitney	.	.	6 55	80c
Mendham	.	.	7 00	80c
Ralston	.	.	7 05	80c
Peapack	.	.	7 25	60c
Pottersville	.	.	7 35	50c
New Germantown			7 50	25c

Notice that the New Jersey & Pennsylvania Railroad, the official name for the Rock-A-Bye Baby Railroad, would run a special train from the Pitney stop in Washington Valley to White House on September 22, 1910 to connect with a special train, for the Allentown (Pa.) fair. (Ralston Historical Assn.)

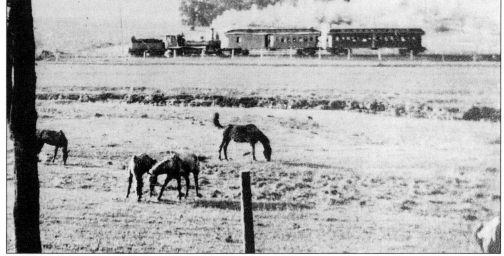

The Rock-A-Bye Baby Railroad in Washington Valley is seen here opposite Lewis Morris County Park. Because the railroad only had a single track and no turntable at the Watnong Depot, the engines pushed or pulled the cars. Much of the roadbed is now Patriot's Path. (Township Archives.)

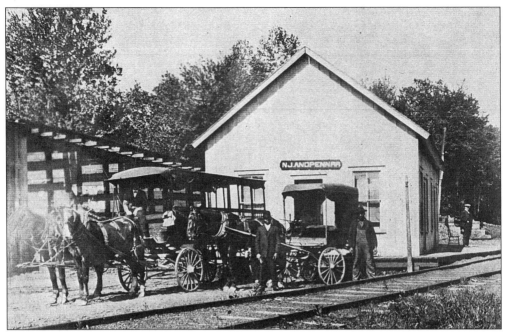

The Watnong Depot of the Rock-A-Bye Baby Railroad, so named because of its rough road bed, is shown in 1906. Stages to carry passengers and mail to Morristown await the trains arrival. (Ralston Historical Assn.)

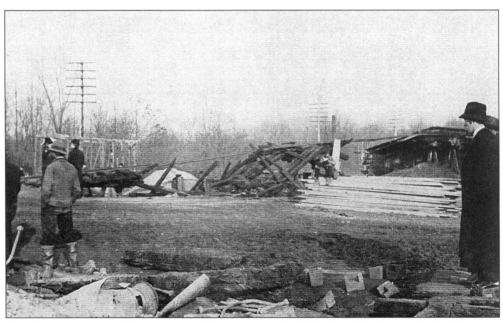

Seen here are the smoking remains of the January 24, 1913 fire that destroyed the Watnong Depot at the Morristown end of the Rock-A-Bye Baby Railroad line. Trestles of the two coal companies and several freight cars are visible. (Ralston Historical Assn.)

Frank B. Allen, president of the Rock-A-Bye Baby Railroad, stands in front of a Model T used to tear up the railroad tracks from Watnong to Mendham in July 1917 at Brookside. (Ralston Historical Assn.)

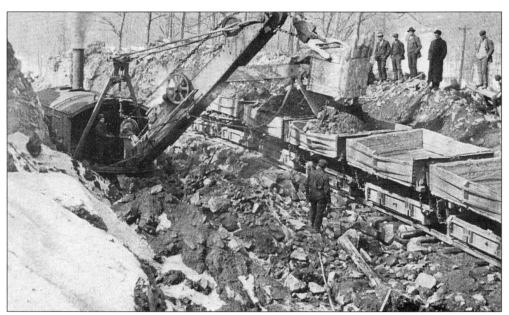

When the railroad went bankrupt in 1913, a sizable cut, portions of which are still visible, had to be excavated to bring the tracks to a connection with the Lackawanna Railroad at Morristown. (Ralston Historical Assn.)

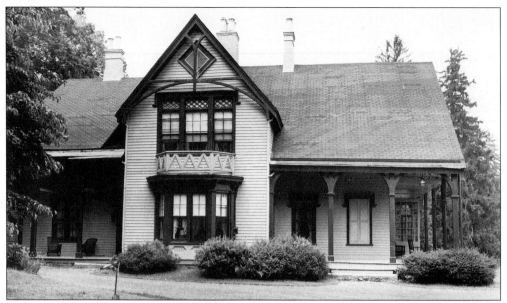

This is a side view of Fosterfields, the mansion of Charles G. Foster on Route 24, originally built by Joseph W. Revere, grandson of Paul Revere of Revolutionary War fame. Among the individuals who rented it was author Francis Bret Harte, who drew the inspiration for his Revolutionary War period novel, *Thankful Blossom*, from the atmosphere of the surrounding Washington Valley farms. (Author's Archives.)

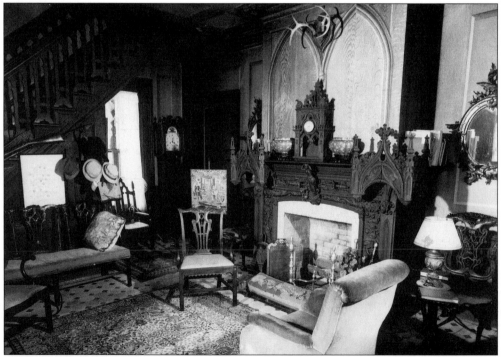

Shown here is the living room at Fosterfields. Originally called "The Willows" by Revere, the 88-acre farm was expanded in 1882 to 258 acres by Foster, a New York commodities broker. (Author's Archives.)

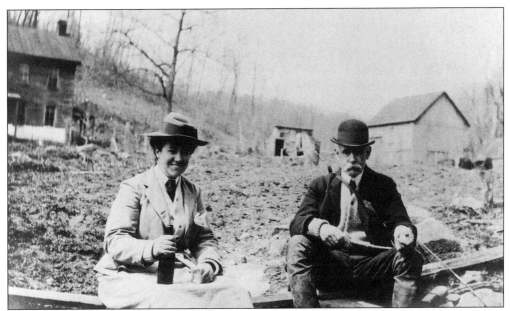

Pictured here are Caroline and her father, Charles G. Foster, at Fosterfields, noted for the murals painted by Revere in the dining room, which depict wild game with a grape vine falling in graceful loops across the top panels. (Author's Archives.)

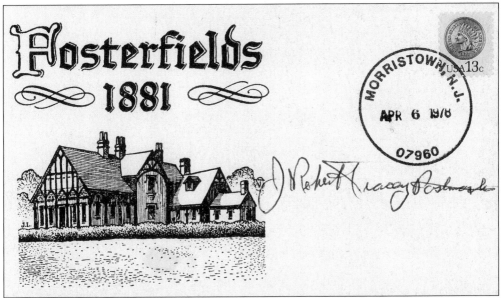

This commemorative envelope was issued by the United States Post Office Department for philatelists in 1978 denoting Fosterfields as a New Jersey Living Historical Farm and Museum by the State Agricultural Society. Previously, it was placed on the National Register of Historic Sites in 1973. (Author's Archives.)

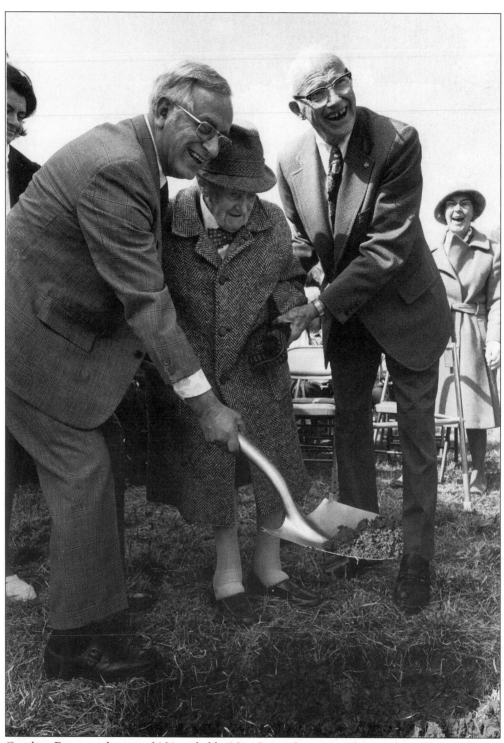

Caroline Foster at the age of 101, aided by New Jersey Secretary of Agriculture Philip Alampi, and William L. Arthur, president of the Morris County Park Commission, break ground on April 6, 1966 for New Jersey's First Living Historical Farm. (Author's Archives.)

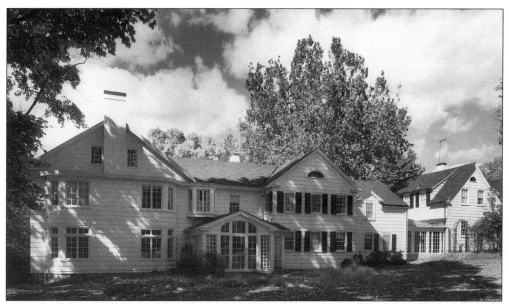

Peacemeal was the homestead of Jacob Arnold, owner of Morristown tavern in which Gen. George Washington made his headquarters in the winter of 1777, on Washington Valley Road. Caught selling applejack made in a local distillery during Prohibition, he was forced to sell off a large portion of his land to pay the fine (Turpin Realtors.)

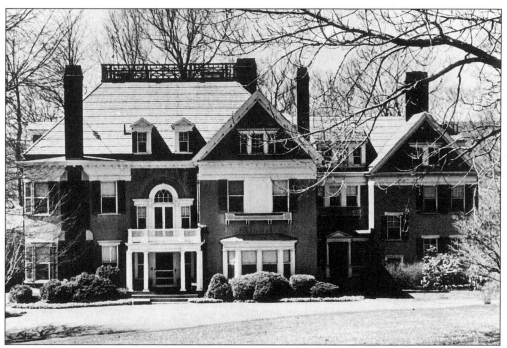

Tranquillity, the 26-room mansion of Walter Schuyler Kemeys, was built in 1904 on a 110-acre estate on Route 24 at Washington Valley Road. It was razed in 1962 to provide land for the National Headquarters of the Seeing Eye Dog Guide School. (Author's Archives.)

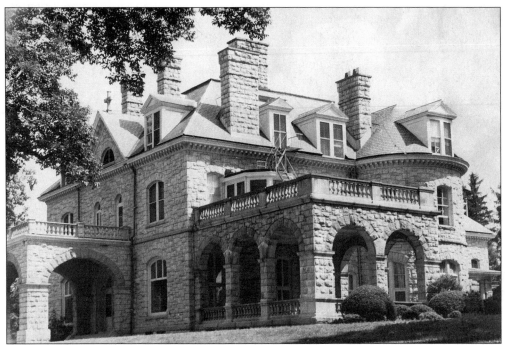

Delbarton, the mansion of Luther Kountze, a New York banker, was constructed on a 4,000-acre estate in 1886 on Route 24 from granite quarried on the property. Prior to 1900 it was simply known as "The Farm." Today, it is Delbarton Preparatory School. (Author's Archives.)

This statuary imported from Italy and Greece by Luther Kountze is shown atop walls and pillars in an intricate Italian garden at Delbarton. Marble pillars for a Greek garden on the opposite side of the mansion, never built, lie abandoned in woodlands on the estate. (Author's Archives.)

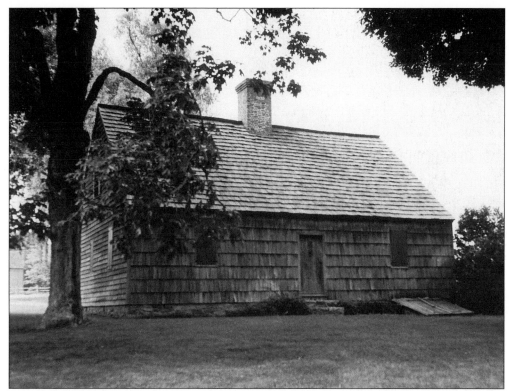

The Tempe Wick House in the Jockey Hollow Area of Morristown National Historic Park, part of Kountze's land, was offered by his heirs to the Washington Association of New Jersey, then to the Daughters of the American Revolution. Neither accepted it, and it waited for development of the national park to be accepted. Kountze wanted the house in which Tempe Wick hid her horse from soldiers to be preserved. (Author's Archives.)

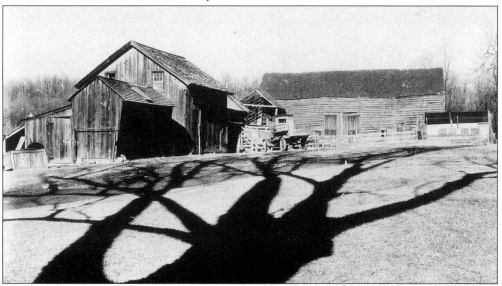

Barns on the Tempe Wick farm were once part of Kountze's 4,000-acre estate and now part of the Jockey Hollow Area of Morristown National Historical Park. (Morristown Library.)

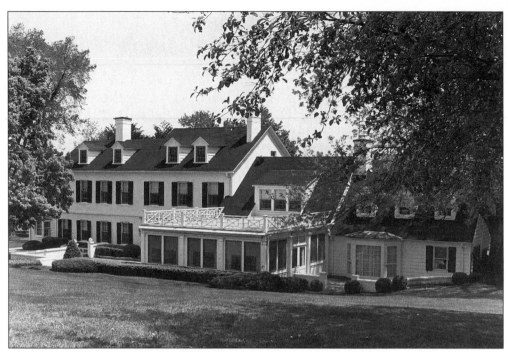

Rolling Acres, a 52-acre estate on Whitehead Road, Washington Valley, was built in the early 1800s. Additions were added in 1949 and 1972. (Author's Archives.)

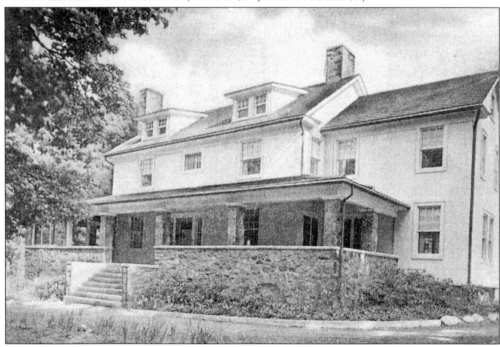

Drum-A-Cairne, a stone and stucco mansion on 22 acres, sits atop a rise overlooking Washington Valley Road, a pond, and the two-acre front lawn. It was built in the mid-1800s for Dr. James Campbell. To the rear of the mansion is a garage and stable, tool house, chicken house for 100 hens, gardens, and an orchard. (Author's Archives.)

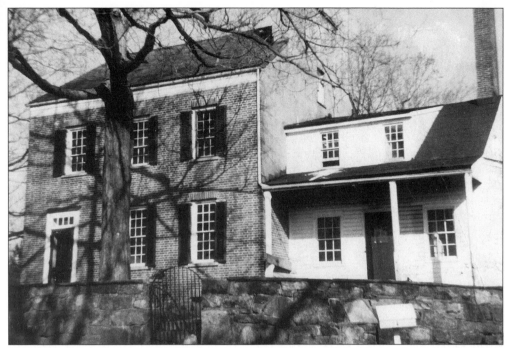

The John Smith house at 124 Washington Valley Road, a Federal period residence built in 1812 on a 140-acre farm, is listed in the National Register of Historic Sites. Bricks for it were made from clay found in lowlands southeast of the house. The frame wing is an 18th-century house moved from farther east, along the Whippany River. (Morristown Library.)

Built by Jacob Smith, an early 19th-century weaver, the two-story frame vernacular cottage at 60 Washington Valley Road is a long, low 18th-century residence with multiple additions. The dry-laid retaining wall at the front of the property is similar to that of his brother John's house. (Morristown Library.)

Kahdena, a mansion on Kahdena Road built by Charles Cutler, a communications magnate, is shown in 1887 on what became known as "Telephone Hill" because of the number of telephone tycoons residing there. The name of the estate, road, and corporation was selected when one of the group of tycoons emptied a box of anagrams, seven letters of which fell in a row spelling "Kahdena." (Author's Archives.)

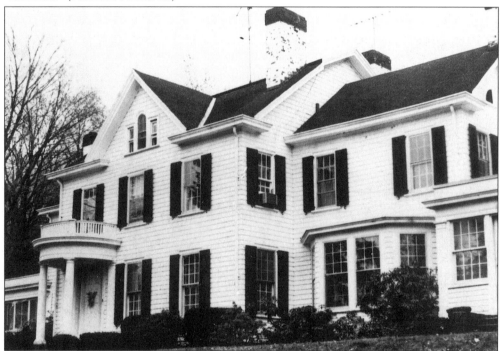

Built by William Sayre, the core of this rambling mansion is an early 19th-century farmhouse, which also functioned as a tavern and inn in the early part of the 1800s, when the Washington Turnpike Route 24 passed its front door. In recent years when it was a boys school it was reported to be haunted. (Author's Archives.)

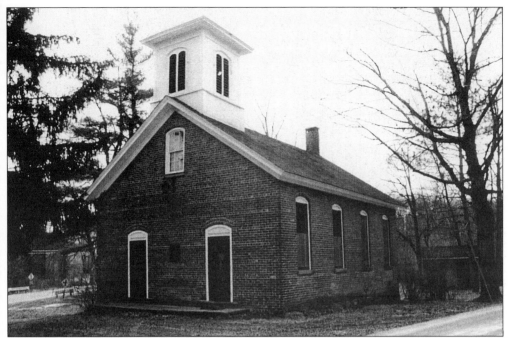

Built in 1865, the Washington Valley Schoolhouse, at the intersection of Washington Valley Road and Schoolhouse Lane, was the only one-room brick school constructed in the 1800s. Listed in the National Register of Historic Places, it continues in use as a community meeting place and social hall. (Sally Foy.)

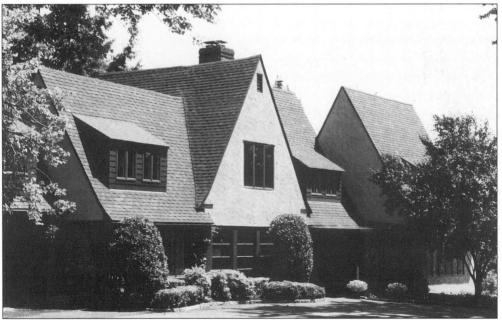

The extensive combination carriage house/stable with servants' quarters above on Knox Hill Road at the Washington Valley estate of Henry Rawles, vice president of the Celluloid Company of Newark, was converted into a private residence after his death in 1923. (Author's Archives.)

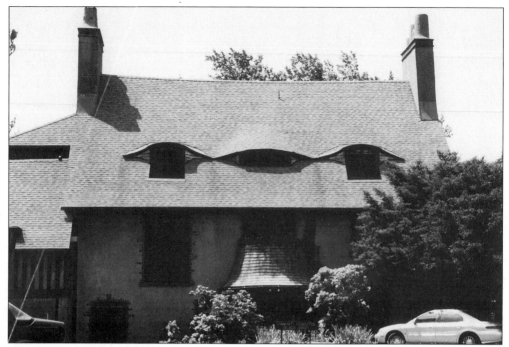

The Henry Rawles mansion on Knox Hill Road, designed by noted architect Harrie T. Lindeberg, is among the seven of ten estates surviving in Washington Valley. Built in 1916, the Tudor-style home was surrounded by gardens and meadows in which the grass was clipped as close as a golf course, enabling neighbors to practice their swing. It was deeded to the Morris County Park Commission in 1976. (Author's Archives.)

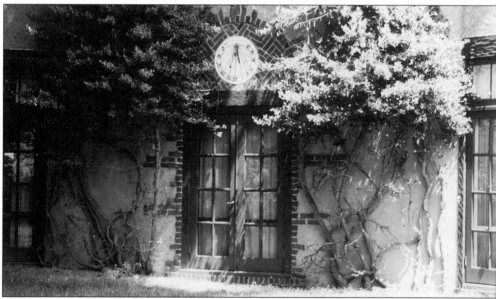

A unique sun dial over a rear terrace door of the 17-room Henry Rawles mansion, which overlooks Washington Valley from the north, is surrounded by vines. Placed on the National Register of Historic Places in 1992, it is now the headquarters of the Community Foundation of Morristown. (Author's Archives.)